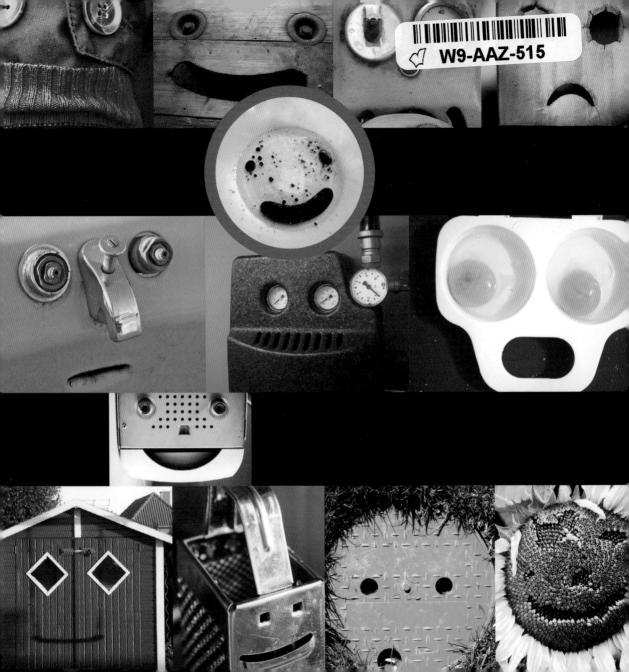

FOCUS:

FOUND FACES

Your World, Your Images

LARK

An Imprint of Sterling Publishing Co., Inc.
New York

WWW.LARKCRAFTS.COM

Senior Editor:
Nicole McConville

Editors:
Julie Hale,
Kathleen McCafferty,
and Beth Sweet

Art Director & Cover Designer:
Travis Medford

Library of Congress Cataloging-in-Publication Data

Focus : found faces : your world, your images. -- 1st ed.
 p. cm.
 Includes index.
 ISBN 978-1-60059-792-3 (alk. paper)
 1. Photography, Artistic. 2. Face in art.
 TR655F623 2011
 770--dc22

 2010028467

10 9 8 7 6 5 4 3 2 1

First Edition

Published by Lark Crafts, An Imprint of Sterling Publishing Co., Inc.
387 Park Avenue South, New York, NY 10016 w

Text © 2011, Lark Crafts, An Imprint of Sterling Publishing Co., Inc.
Photography © 2011, Artist/Photographer

Distributed in Canada by Sterling Publishing,
c/o Canadian Manda Group, 165 Dufferin Street
Toronto, Ontario, Canada M6K 3H6

Distributed in the United Kingdom by GMC Distribution Services,
Castle Place, 166 High Street, Lewes, East Sussex, England BN7 1XU

Distributed in Australia by Capricorn Link (Australia) Pty Ltd.,
P.O. Box 704, Windsor, NSW 2756 Australia

If you have questions or comments about this book, please contact:
Lark Crafts
67 Broadway
Asheville, NC 28801
828-253-0467

Manufactured in China

ISBN 13: 978-1-60059-792-3

For information about custom editions, special sales, and premium or corporate purchases, please contact Sterling Special Sales Department at 800-805-5489 or specialsales@sterlingpub.com.

For information about desk and examination copies available to college and university professors, requests must be submitted to academic@larkbooks.com. Our complete policy can be found at www.larkcrafts.com.

Page 7
Jean-Yves Leblon
The Vinaigrette Man

Contents

fo • cus: a central point of attraction

Your World

When walking down a busy city street or strolling through a wooded park, do you scan your surroundings with hungry eyes? Do you find yourself on a visual safari hunting snapshots of beauty, intrigue, or surprise amid the ordinary fodder of the everyday? All of us, from professionals to beginners, can take engaging and even breathtaking photographs just by observing the world around us. Meaningful images are everywhere, just waiting to be spotted and captured.

Your Images

Visit any number of online image-hosting sites, and you'll quickly realize how eager we are to snap, organize, and share what we see—in the form of millions upon millions of digital images. Technology has not only provided the tools, it has also fostered a vibrant community ready to embrace and encourage our infatuation with the visual image.

The Series

In *Focus: Found Faces*, the third entry in the Focus series, this community has made plain its fascination with revealing what is often right in front of our eyes: faces in very unexpected places. Warehouse windows stare back at the viewer, electrical outlets are suddenly surprised, pieces of cheese seem to be singing, and a sweater cuff grins from its folds. When asked how they find these faces, many photographers responded that they did not, in fact, do the finding—the faces found *them*. Is it part of our core nature to subconsciously hunt for and recognize human features in the world around us? Could it be that we are conditioned to perpetually seek out fellow faces, even when those faces are in a leaf, a parking meter, or a ship's anchor? Take a look around you—what do you see?

The Focus

Faces are our direct link with those around us: they communicate our emotions and the deepest parts of ourselves often without the need of language or gestures. Faces are also the filters through which we deliver and interpret information: they conceal and reveal the true essence of our intentional and unconscious selves. Finding faces in the world can be comforting, disconcerting, even mesmerizing. Their unexpected nature may be why we find them so fascinating.

Within these pages you'll discover the work of over 90 photographers from 26 different countries, along with their reflections on the compelling art of finding faces. Their photos and words range from hilarity to mystery, and many reflect the surprising delight we feel when we, too, encounter found faces.

Peruse, and discover the magic before your eyes.

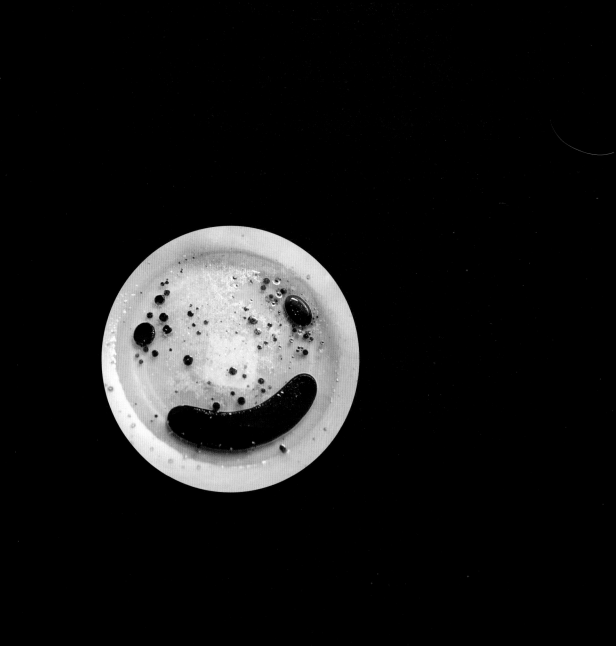

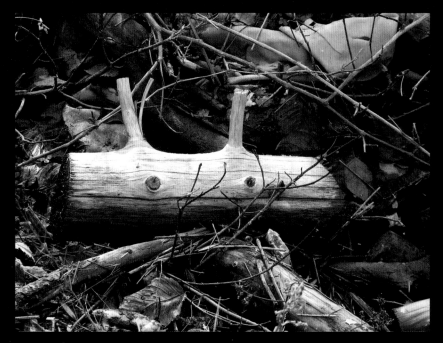

Martin Ujlaki
I Come in Peace

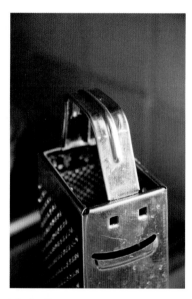

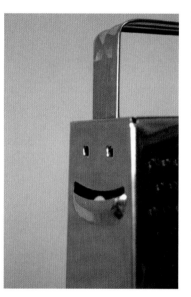

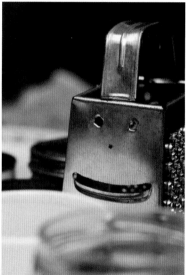

Freiya Benson
Cheesegrater Smile
My found face lives in my kitchen.
He's a very happy grater.

Rudolf Csiba
Grater
Did the designers plan that the openings
on this grater would form a face, or is it
just a coincidence? I've always wondered.

Peter Jackson
He Might Be Smiling But...
(You Don't Want to Rub Him the
Wrong Way)

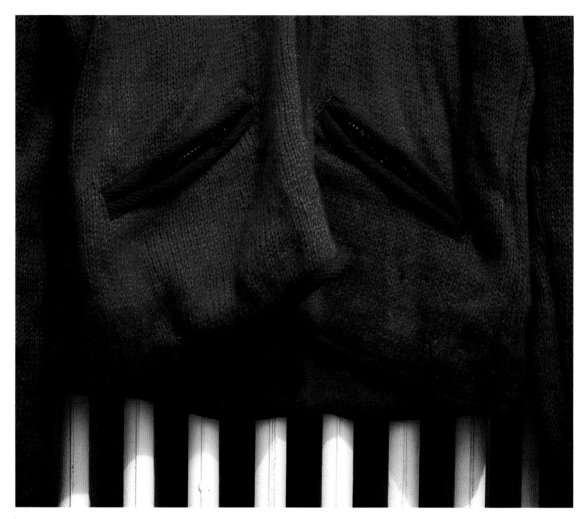

David Dunsmore
Face Cardy

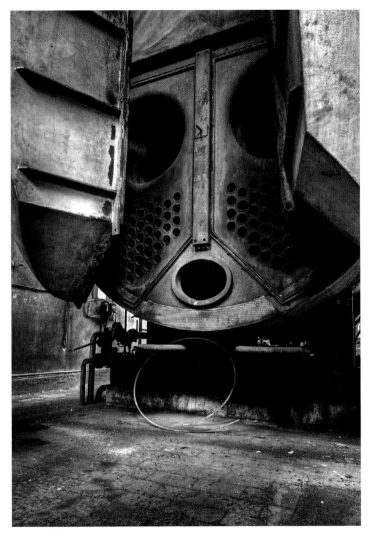

Franck Losay
Steel Face

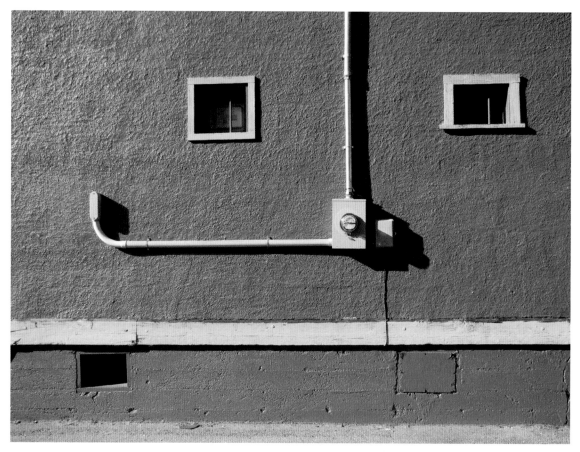

Drew Makepeace
Wall Face
I don't actively look for faces; they pop out at me when I least expect it. It's like the faces
are finding me rather than the other way around.

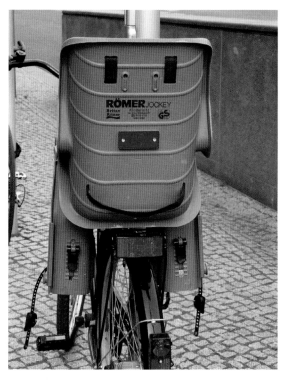

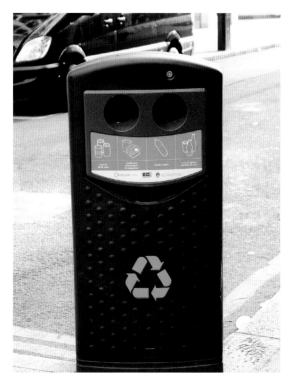

Habacuque Nakazato Lima
Ride My Bike
When I discover a face in anything that shouldn't be a face, I get really happy. It's funny how the whole world can be so different when you look at it from a different point of view.

Hayley Griffith
Trash Talkin'
It's not so much discovering faces that appeals to me. It's the fact that, once you start to see them, you can't stop seeing them. The cereal in your bowl becomes lots of smirking little smiles and dozens of little eyes. The trunk of a tree is transformed into a wise old face. Once you start, it's impossible to stop. But why would you want to?

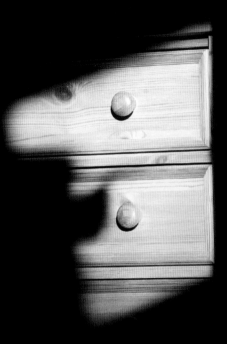

Dr. Jan Daugart
My Laughing Commode

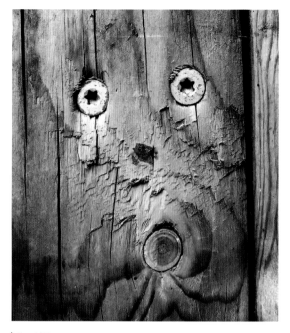

David Dunsmore
Woodface

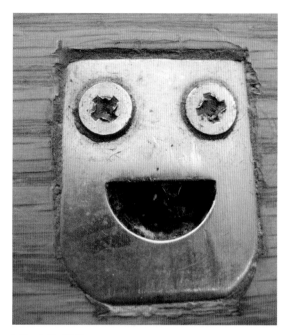

Charlotte Walton
Door Plate Says Hi

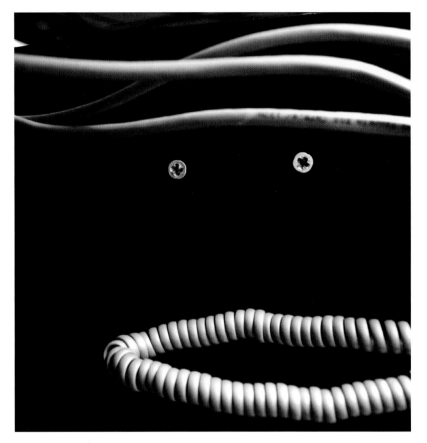

Georgescu Cătălin Cristian
Rasta Mana
This face is made out of the wires and cables that dangle from the side of my desk. They caught my eye while I was resting in bed with my head tilted sideways. I stared at the screws and began to see the face of a rasta man with braided hair. And no, I did not set this shot up.

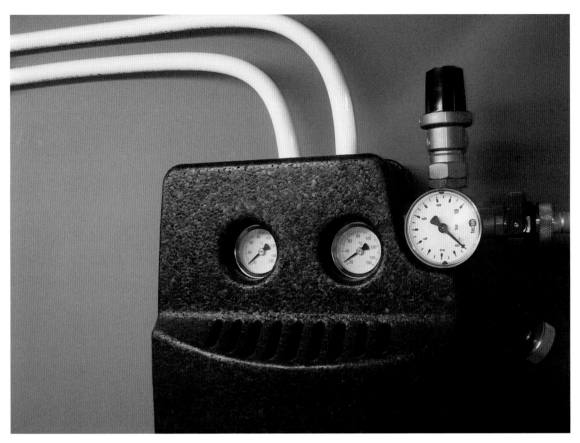

Robert Pataki
Steamboy
I met this guy in a home supply store looking for some new stuff for my parents' flat. It is a kind of sun-energy driven steam boiler. The meters and the holes on it give him a very characteristic face.

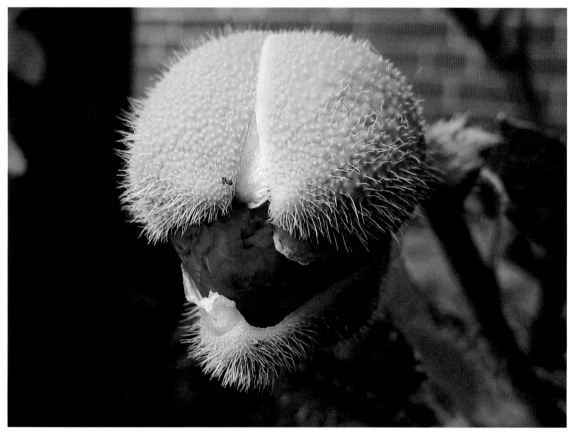

Peter Gubatz
Piranha Plant
By coincidence I often discover faces at home, in my village, in my garden, in the supermarket—everywhere!
Discovering a face, even on an unusual object, is such a nice thing—it's a bit like making a new friend.

Valéne Joly
La Sentinelle du Haut Koenigsbourg

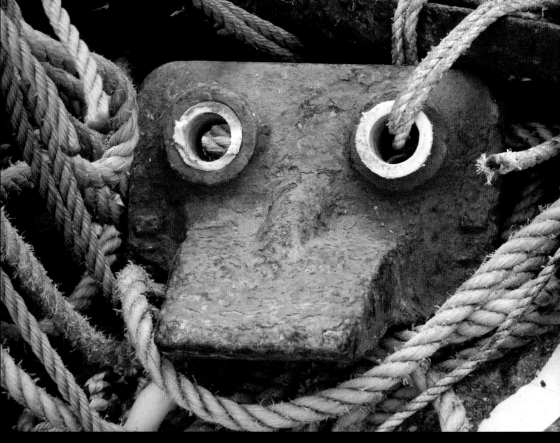

Cathy McBurney
Mr. Bignose

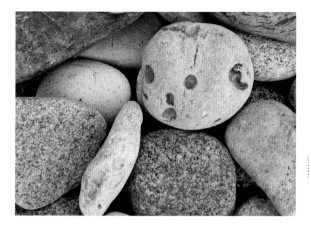

Sandra Mullender
Beach Baby
I found this poor abandoned baby on Seaham Beach last summer, during one of my evening walks. It seemed a shame to leave him on his own, so I brought him home with me to live on my cairn.

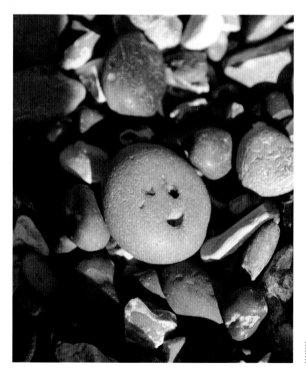

Anna Mair
Pebble Face

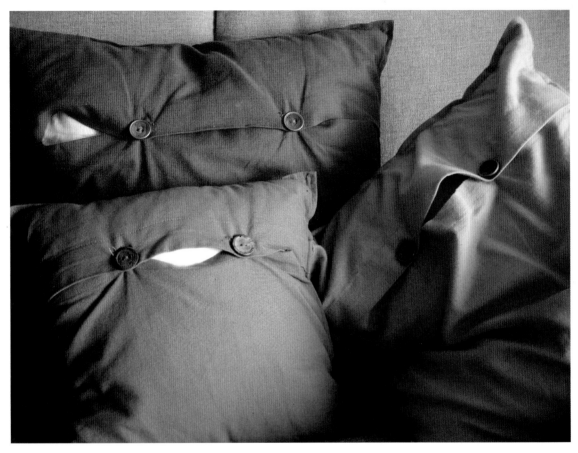

Tarabout Frédéric
Trio
Some friends who know my love of smileys told me about these cushions which look like
funny customizable faces. I couldn't resist and bought this whole family!

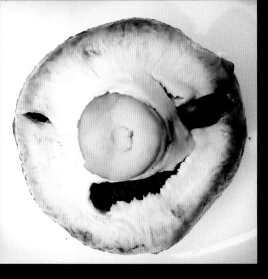

David Dunsmore
A Fun Guy
I guess I'm what you would have to call a "pareidolic" (I'm sure I've made this word up!)—one who is addicted to finding faces.

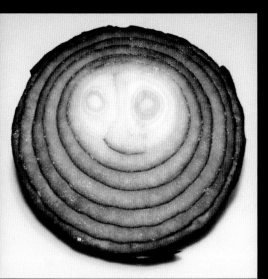

Lily Taylor
Happy Onion
I was helping my Mom with the cooking when I noticed a face smiling at me from the onion!

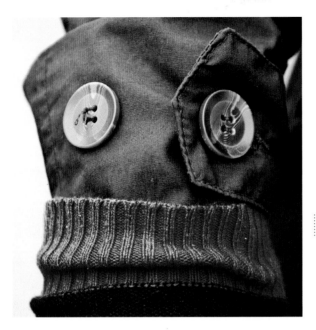

Georgescu Cătălin Cristian
Monocle
On one of my runs through the city streets, I met up with a friend of mine. As we chatted, I noticed the buttons on the sleeve of her jacket. They formed a face, a British academician's face—the straight face of a man who has seen too much during his lifetime. The monocle is a testament to his knowledge.

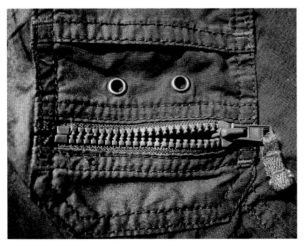

David Dunsmore
Zippy

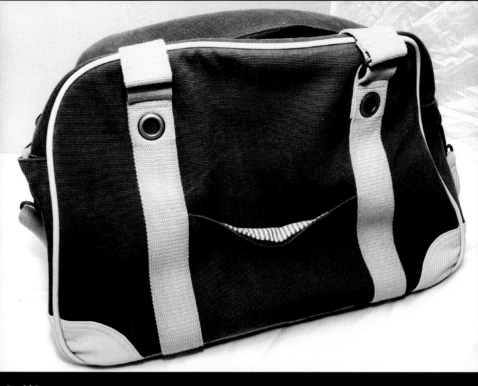

David Dunsmore
Man Bag

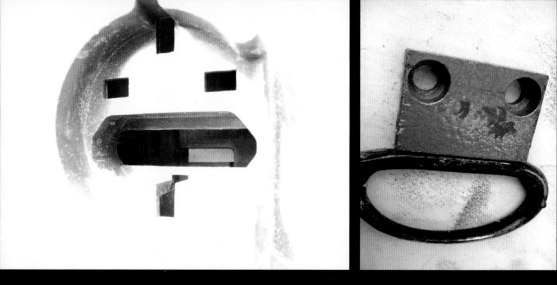

Robert Pataki
The Most Epic Moment of Müngar Tortar

Christian John Olsen
Bigmouth

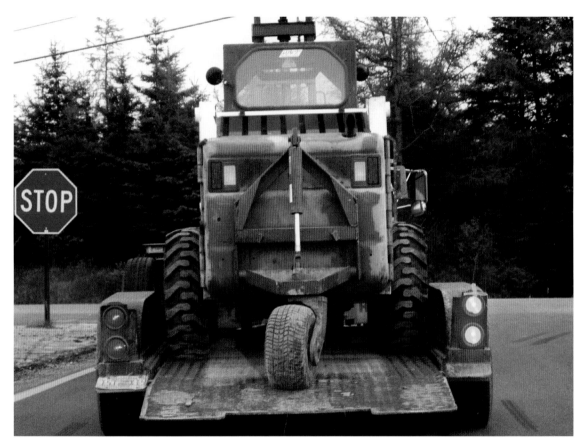

Holly Garner-Jackson
Keep on Trucking

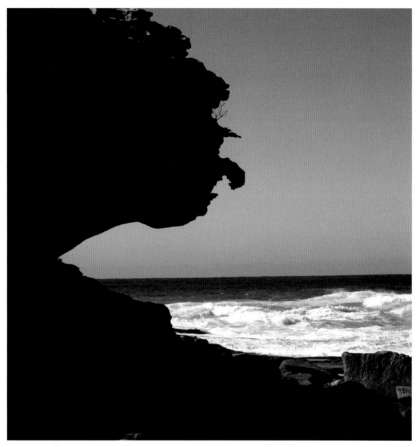

Janit Nanavati
Ancient Warrior Eagle Beak Nose Guarding Tamarama Beach

Colleen Gustavson
Varuna

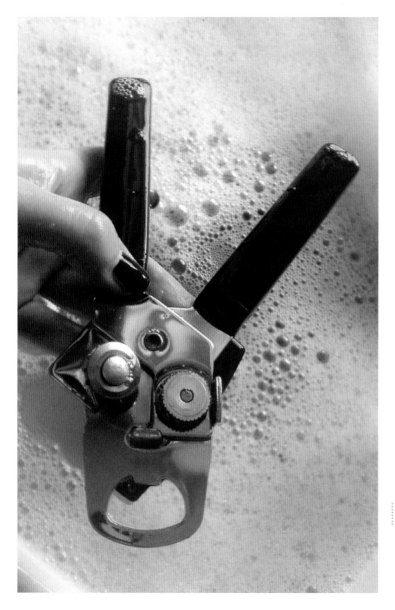

Donna Nicholson-Arnott
Crazed Rabbit Can Opener
How many times have I been playing at making faces with the can opener while supposedly washing the dishes? Too many times! I thought photographing it might get it out of my system.

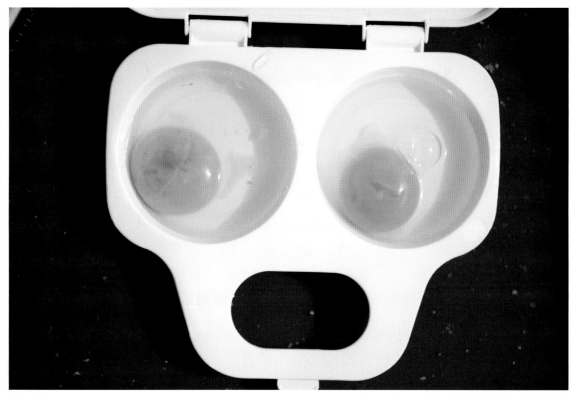

Tim Simpson

How Do You Like Your Eggs?

This image is composed of my breakfast. I was having a new kitchen installed and couldn't boil my weekend eggs, so I bought a microwave egg cooker. One Saturday morning, this face appeared, looking at me, slightly shocked about what was going to happen.

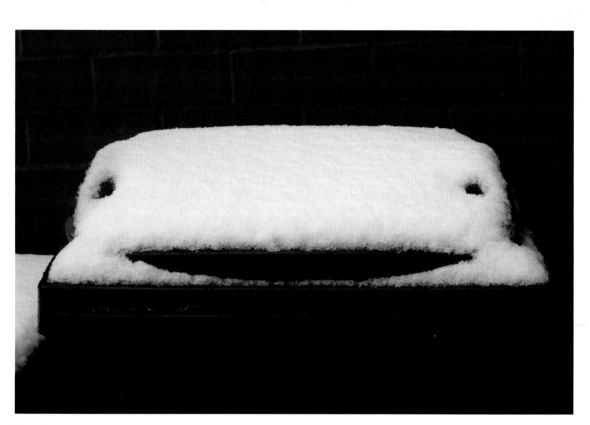

Heidi Linda
Smiley Bin

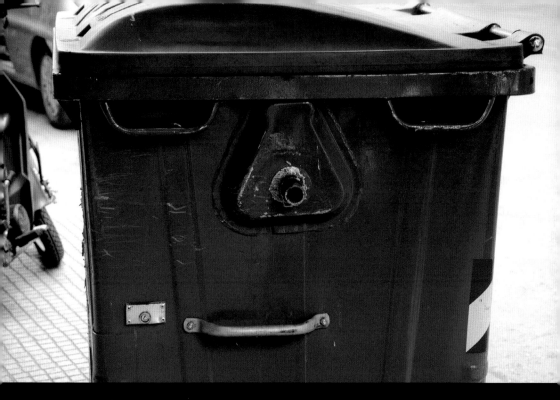

Vanessa Landry-Claverie
Greece (Garbage Face)
On vacation in Greece, walking in Thessaloniki, ALL the garbage pails were looking at me, so I decided to take a picture of one of them. I find it funny that our imagination can see faces everywhere. Clearly our brains are trained to find human-like features in everything.

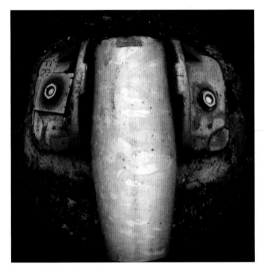

Steve Wrigley
Robo Gonzo

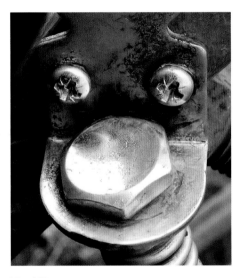

David Dunsmore
Spring Face

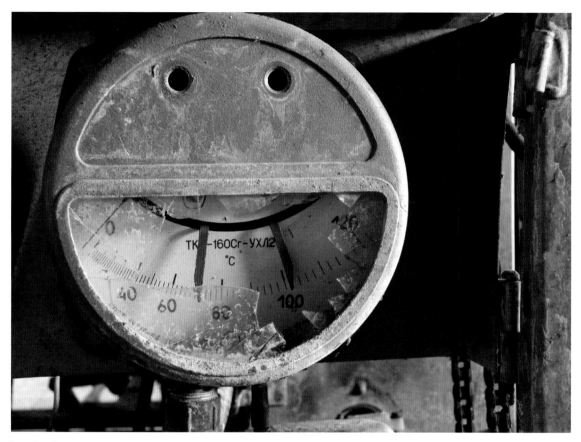

Xavier Llopart Duarte
Dracukramp

Cheryl Denise Whitestone
The Scream Marble Cake Face

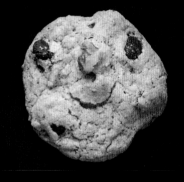

Marilyn Phillippi
Cookieface Has a Heart
I'd just removed a sheet of chocolate chip cookies from the oven, when I saw this funny little face smiling up at me. My granddaughter noticed that Cookieface had a little chocolate heart. Needless to say, Cookieface escaped consumption and lived a long, happy life on the kitchen counter.

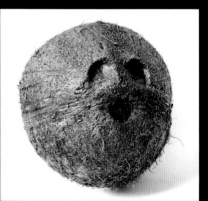

David Dunsmore
Shy Coconut

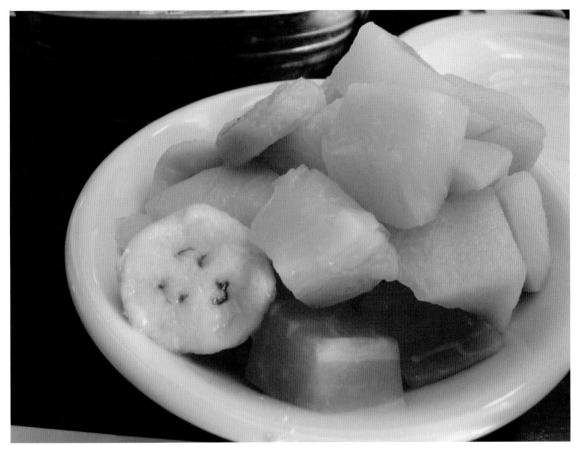

Holly Garner-Jackson
Breakfast with a Smile

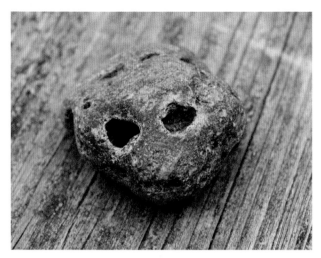

Peter Jackson
A Friend Said, "Baby Seal"

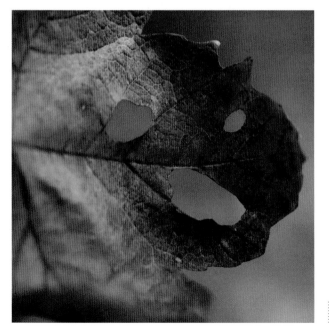

Tanguy DuPasquier
L'Homme Feuille

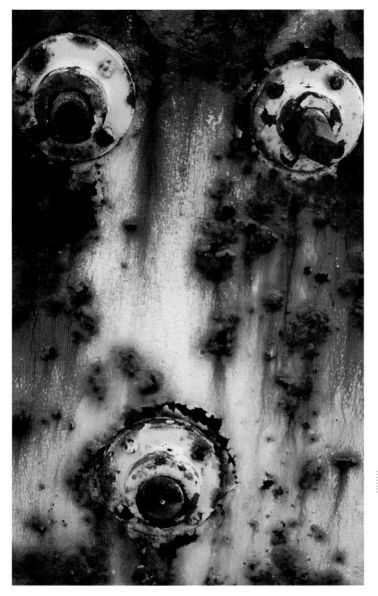

Esther Kiehl
Dungeness Rust Face
I love Dungeness beach, a shingle beach promontory in the county of Kent in England. It's exposed to damp coastal winds that corrode anything metal left on the beach. This is a face that I spotted there on the side of a winch. I like how all three bolts are different!

Xavier Llopart Duarte
Very Sad

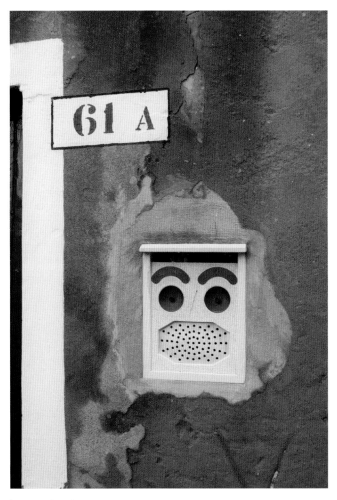

Deb Malewski
Smiley Face Shout-Out

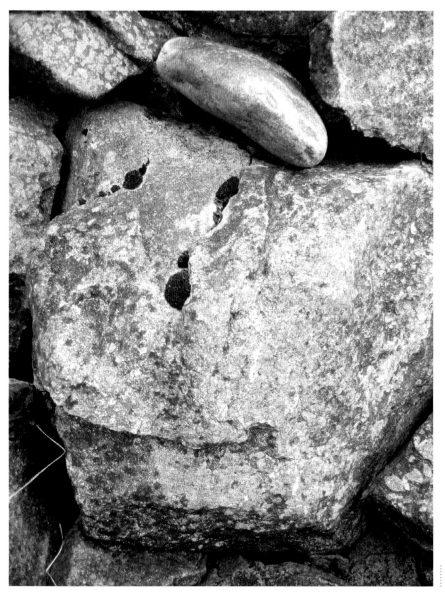

Holly Garner-Jackson
Rocky

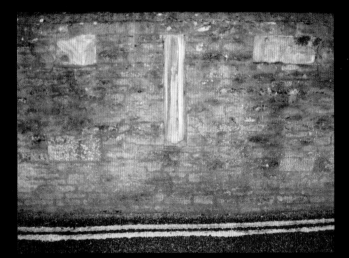

Adam Pelling-Deeves
Disappointed Wall

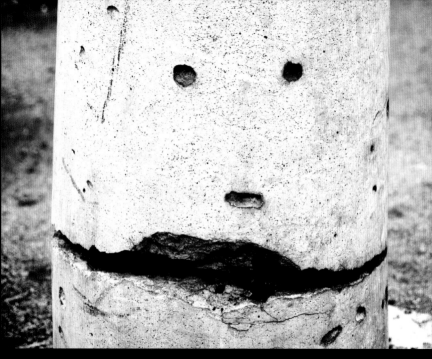

David Dunsmore
Talking Bollards

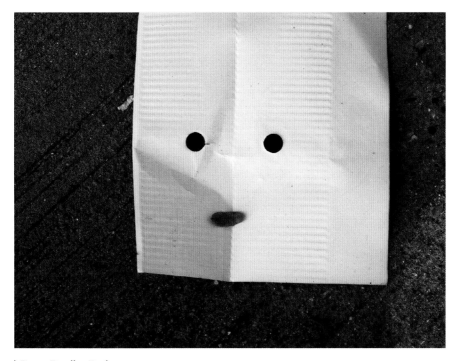

Renee Rendler-Kaplan
Sometimes the Universe Tries to Get in Touch in Unusual Ways
As I left the dry cleaners loaded up with plastic bags and hangers, I spied this face on the ground. Was it a message from the universe telling me to look around and "see," even while running the most mundane of errands?

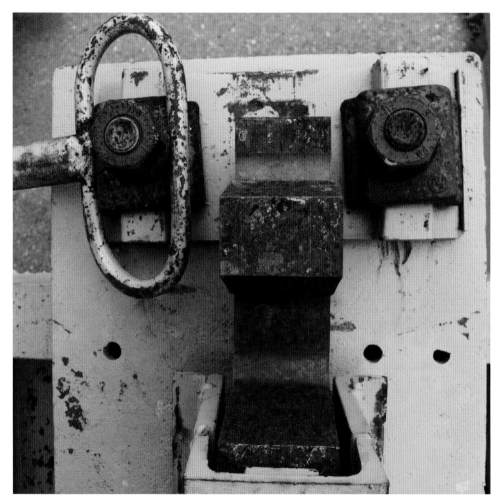

Tanguy DuPasquier
Detective

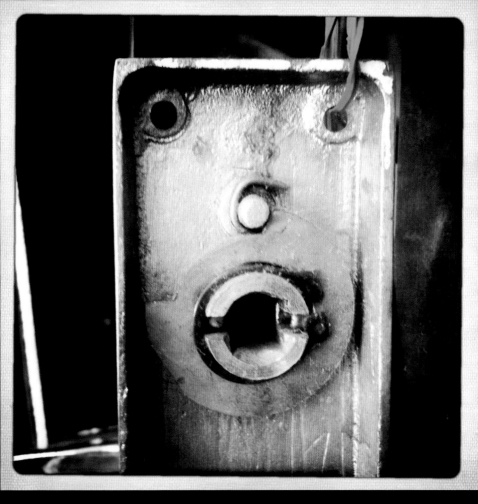

Steve Wrigley
Reverse Handle Man

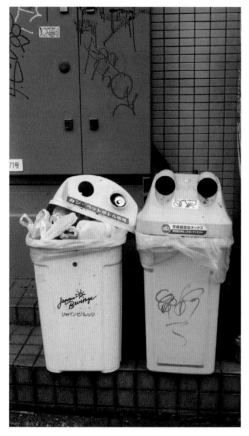

Will Ng Ka Fai
Recycle Bins in Harajuku

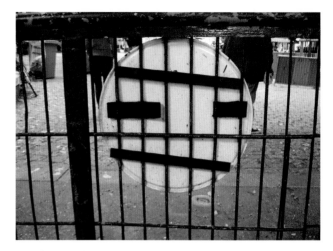

Tarabout Frédéric
1:/

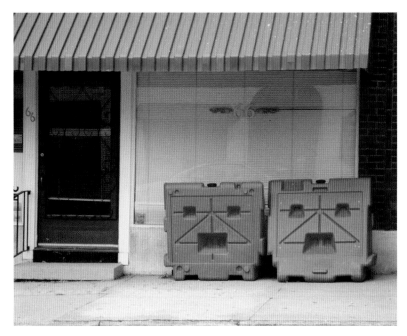

zen Sutherland
Construction Halloween

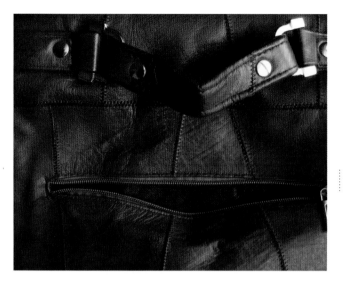

Györi Szabolcs
Attack of the Bag Man
This was only a red bag—I saw it every day, sitting on the desk, boring and harmless until THAT moment! This little red monster suddenly showed his real face: He was looking at me with that funny evil smile, and I realized our relationship wouldn't be the same anymore!

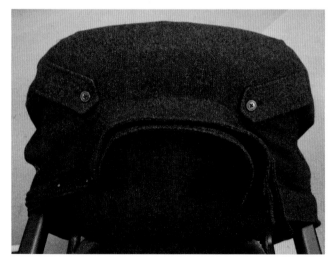

Adam Pelling-Deeves
Disgruntled Frogcoatchair

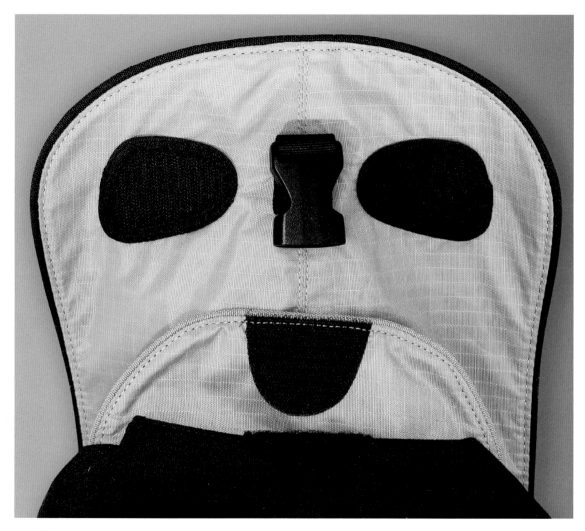

David Dunsmore
Camera Bag Face

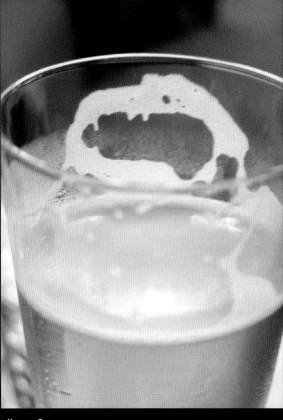

Jimmy Gunawan
Beer Monster

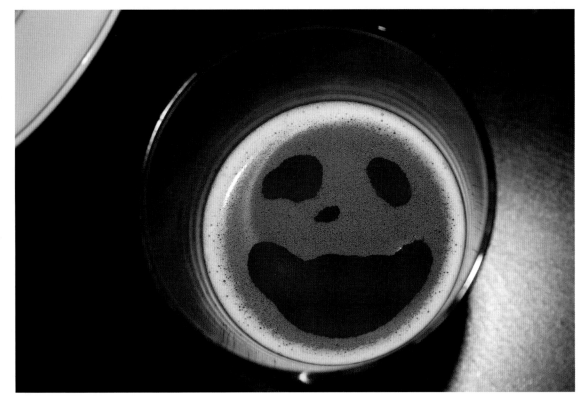

Mattia Mionetto
Jack's Beer
I was at a party when I saw the face of Jack Skellington, a character from *The Nightmare Before Christmas*, emerging from the foam of my beer. I took this photo immediately. It was a spontaneous reaction, not a planned shot, and the result—not very professional— proves it. But I like this photo. It's simple, spontaneous, and funny!

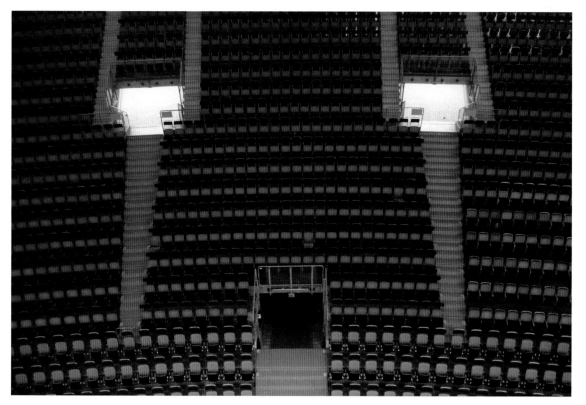

Sandra Hartung
Sad Face

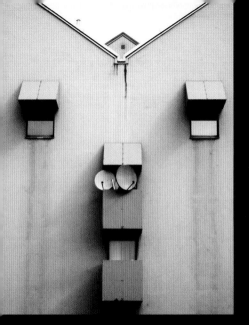

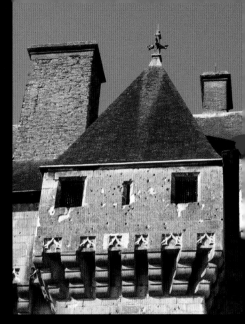

Marco Bellucci
Sad
I was visiting Berlin when I found this strange house. Is it crying? I discovered later that it was the contribution of John Hejduk, the famous architect, to the Berlin IBA 87

Valéne Joly
La Gardien du Château de Langeais

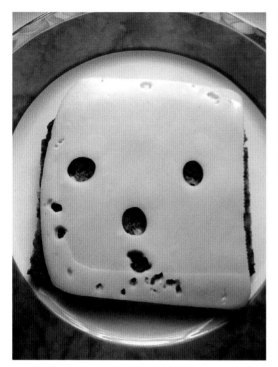

Tassoula E. Kokkoris
When Food Makes a Face
One night I was in a hurry to get dinner prepared and carelessly threw the ingredients into the oven without really paying attention. I nearly jumped when I retrieved the dish—my dinner was clearly mad at me.

Peter Gubatz
Mr. Cheesy Needs to Shave

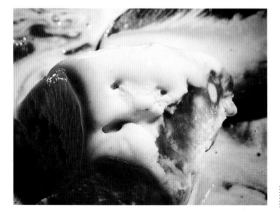

David Dunsmore
Eyes Cream Face

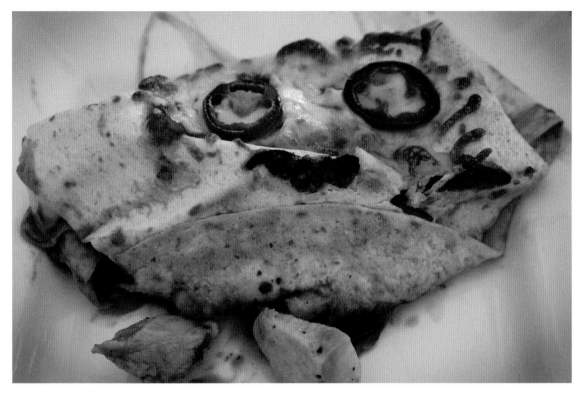

Carl Andersson
The Death of Mr. Wrap

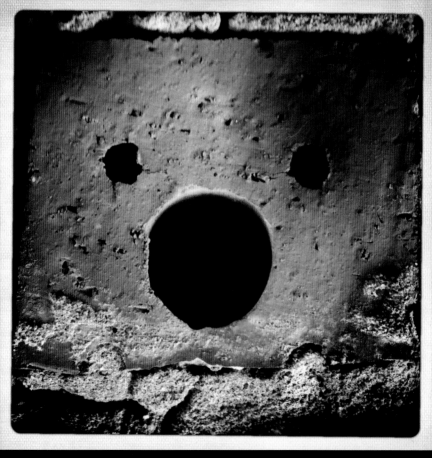

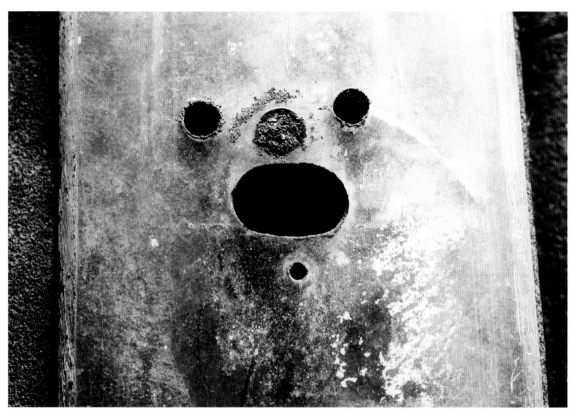

David Dunsmore
Old Doorbell Face

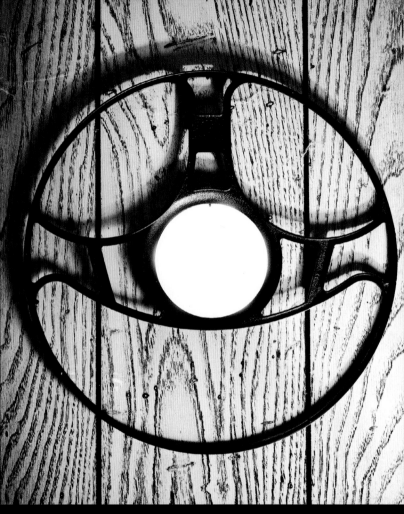

Greg Booher
Evil Clown
Humans seem to have an innate ability to find facial patterns. Perhaps it's an attempt to find order in the randomness of the natural world. I look for faces everywhere. You never know where one will show up.

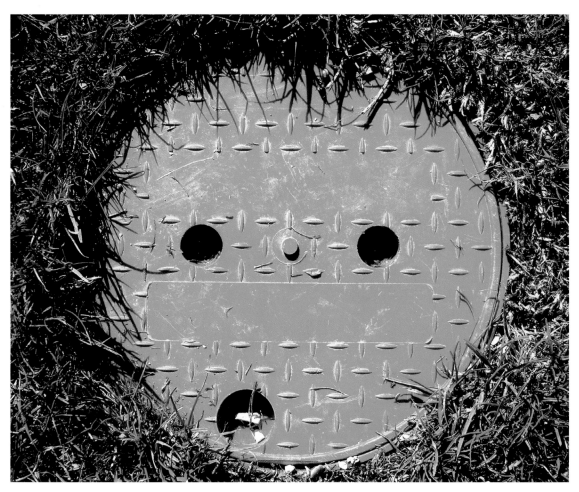

David Dunsmore
Drain Brain

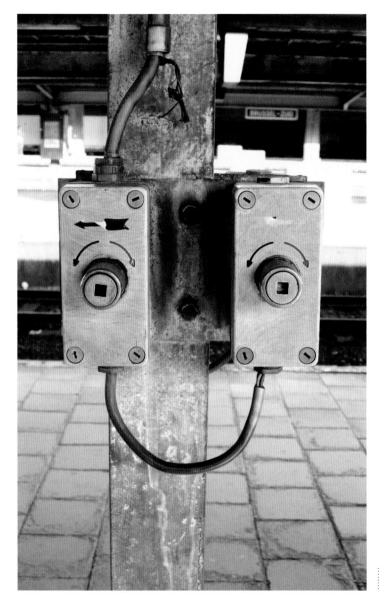

Koen Vadnendriessche
Cheerful

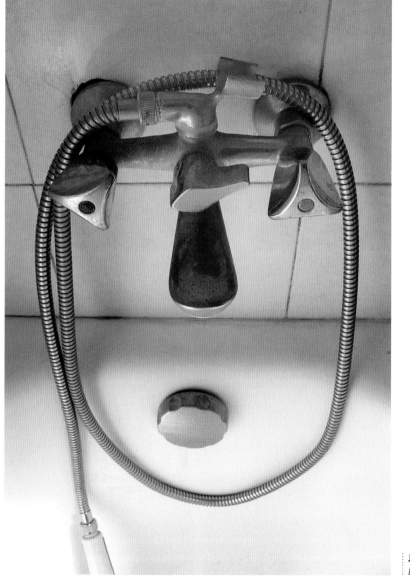

John Fullard
Depressed Taps

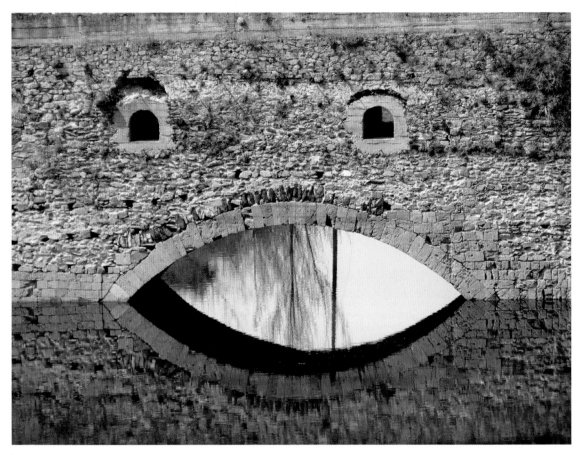

Paloma Rubio Saiz
Frog Face

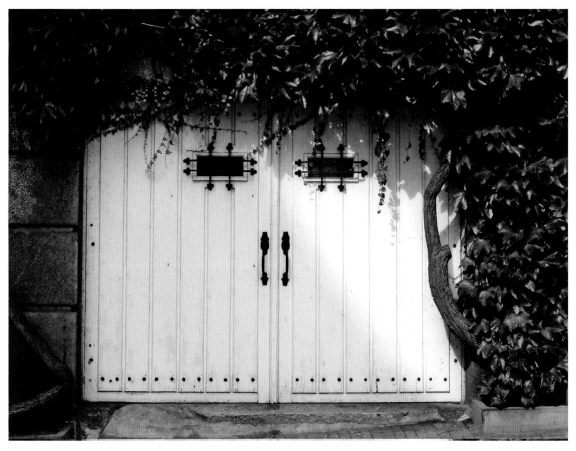

Luis Ricardo Sánchez Moro
Natural Hair

Cheryl Denise Whitestone
Fresh Gerber Man

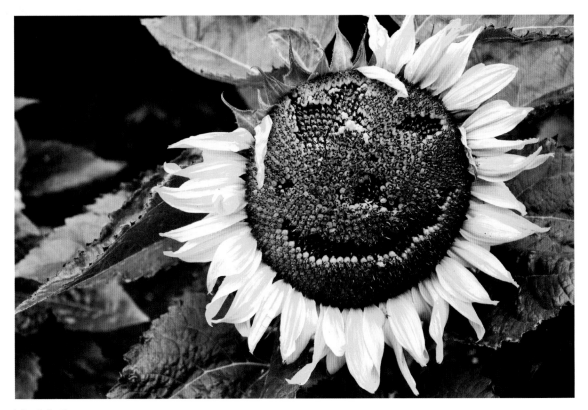

Danielle Cosme
A Seedy Smile

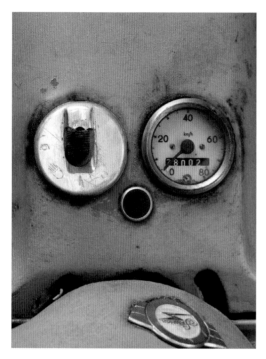

Ulrich Nottrodt
What You See Isn't What You Get!

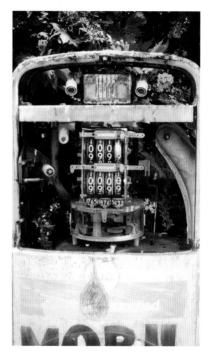

Jimmy Gunawan
Machine Face

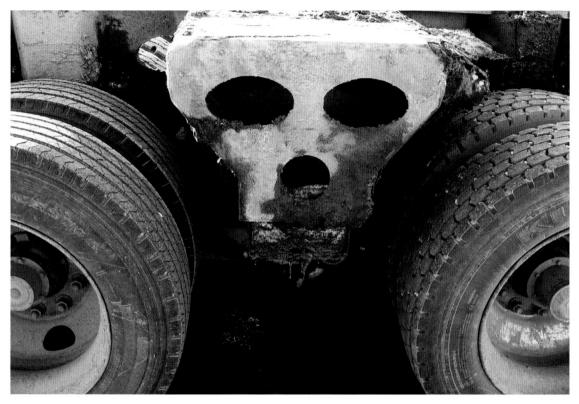

Colleen Gustavson
Eeeerie

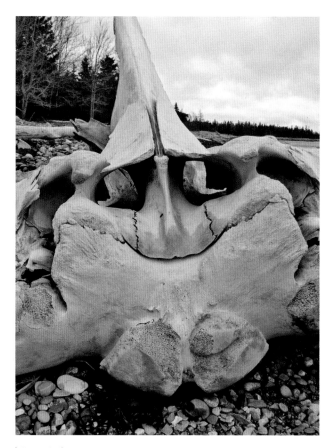

Peter Jackson
The Chubby Wizard
It's a sad and awesome experience to come across whalebones that have washed up from the sea. This skeleton had a very goofy expression, and it took me by surprise. The section of it that's upside down is the whale's skull. I found the bones on Beal's Island in Maine.

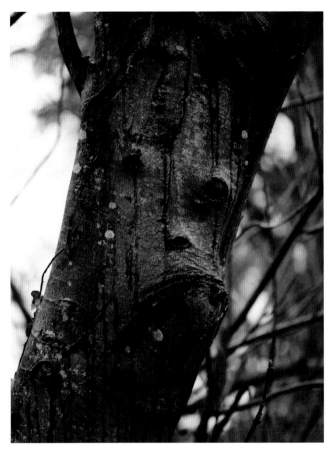

John Gleeson
Untitled

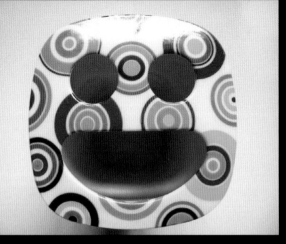

Paula Carolina Zuñiga Garcés
Cepilla Dientes

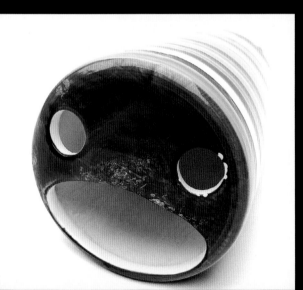

David Dunsmore
Toothbrush Holder Face

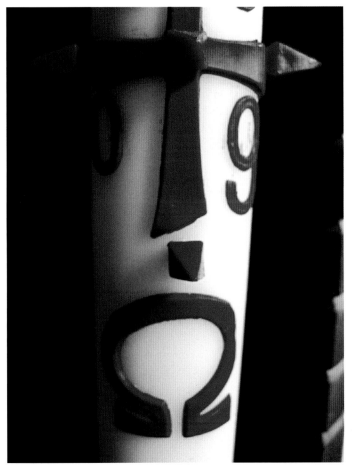

Peter Gubatz
Candleface

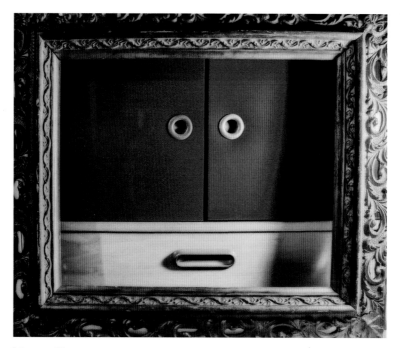

Jacques Marcoux
Meet the Cabinet

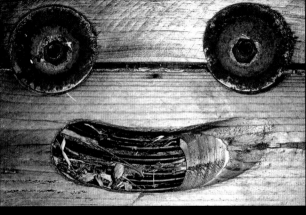

Angel Martinez Martinez
Sometimes I See . . . Faces!

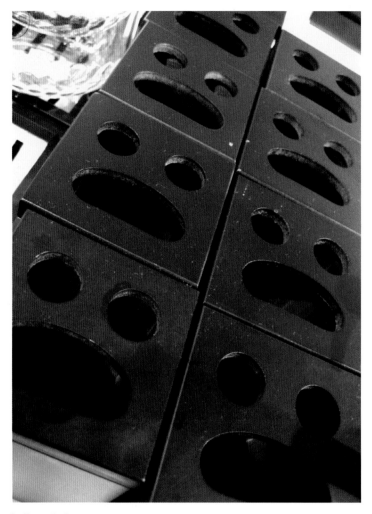

Alison Clarke
The Horror
I believe these are toothbrush holders. I passed them in a chain store that
sells home furnishings, and their Munch-like pain was just too brutal to
ignore. I don't seek these things out—they find me.

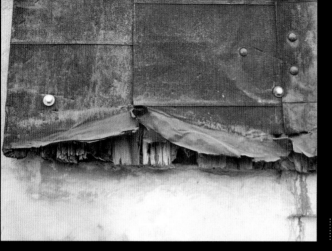

Cheryl Denise Whitestone
Metal and Wood Chipmunk Face

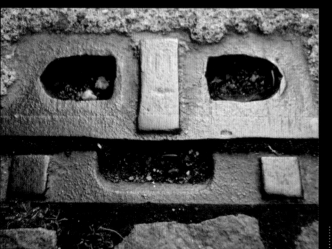

Patrick Dinneen
Iron Man

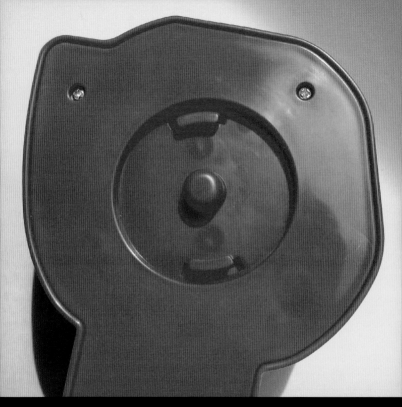

David Dunsmore
Stroller Face

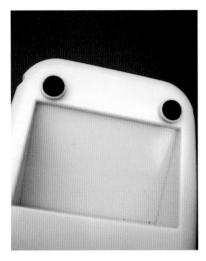

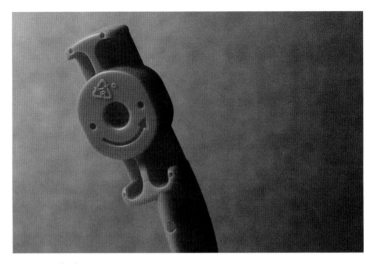

Christian John Olsen
Yellow Face

Dan Mogford
Happy Little Inkjet Fella
This is the protector cap from an inkjet cartridge. I wonder if the person who designed this component wanted to bring a little cheer into an otherwise mundane procedure.

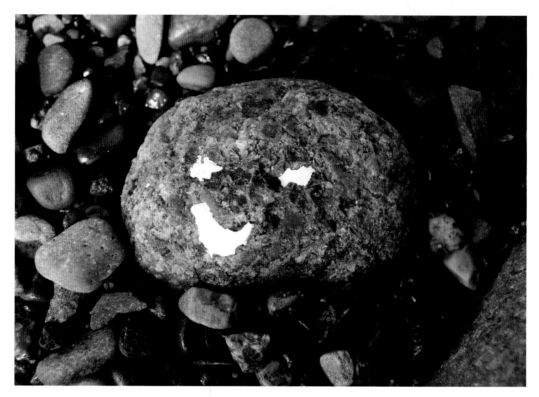

Holly Garner-Jackson
Barnacle Smile
I found this small stone on Campobello Island in New Brunswick, Canada. I stepped over it and paused. Did I see what I thought I saw? I took another look and found this rock. The face was made by barnacles that had once been attached to the rock, but had been broken off by the surf.

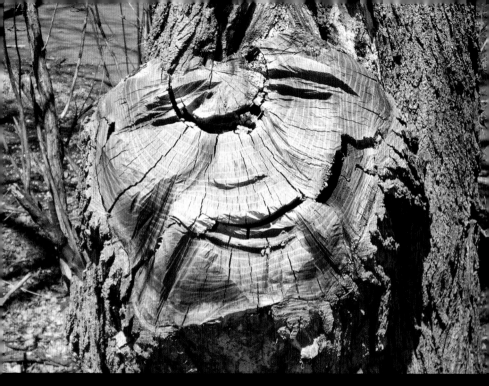

Seth Heiserman
A Wooden Face at Como Zoo
The ability to see and recognize a face is central to our social nature. People can spot faces quickly (one of the reasons soldiers wear makeup is to break up the lines of their faces).

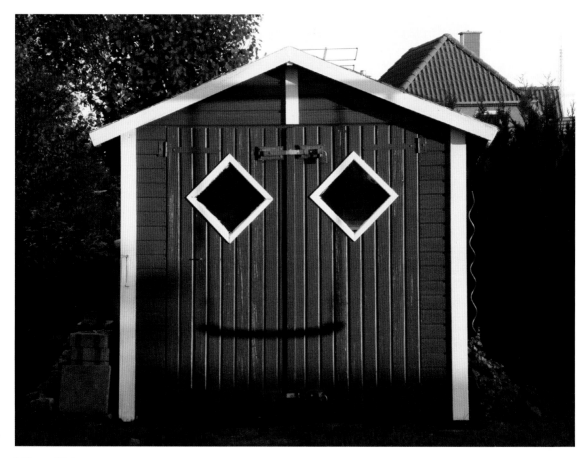

Marcus Böckmann
Smiling Hovel

Abigail N. Haffelt
Staple Face: Taking a Beating

David Dunsmore
Toy Sword Face

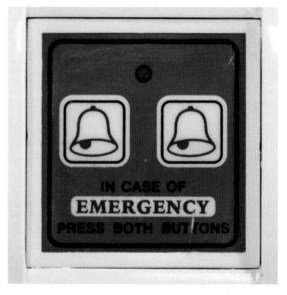

Tarabout Frédéric
>_>

This is the emergency button of my flat in India. I've been hunting faces for two years now, but it took me three weeks to spot this one in my own house!

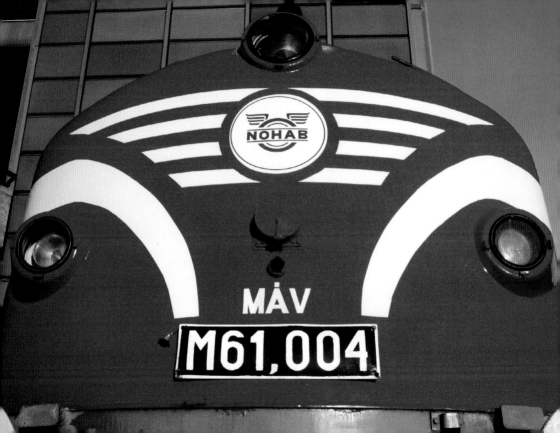

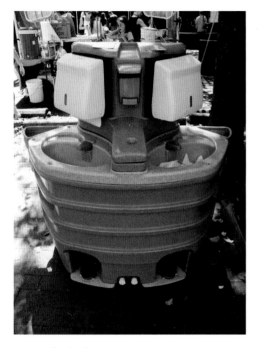

zen Sutherland
Water Face

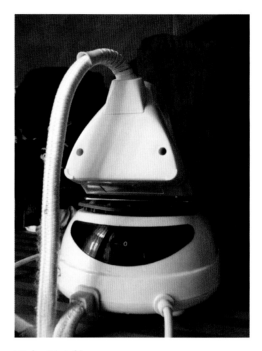

Robert Pataki
The Real Iron Man
Iron Man was an iron I had in Budapest.
He happily helped me with my wardrobe.

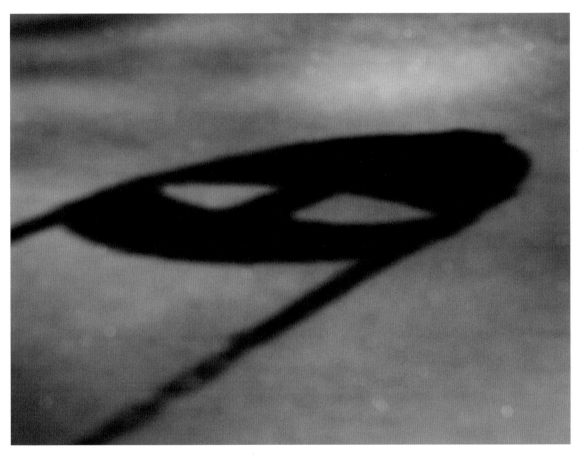

Renee Rendler-Kaplan
Alien Sighting in the Playground
This "sighting" took place on a cold day in Devonshire Park while I was out walking the dog.
Clearly, we were being invaded by aliens.

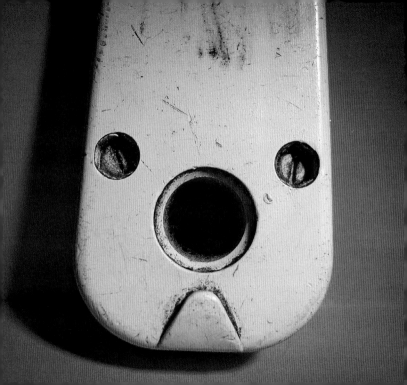

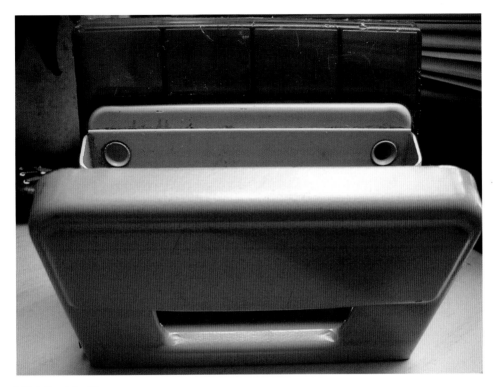

Christian John Olsen
Punchy

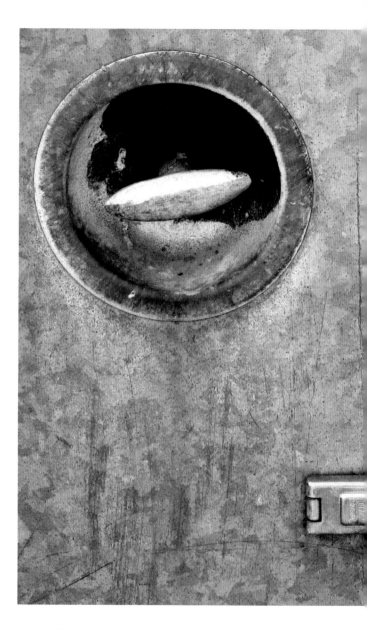

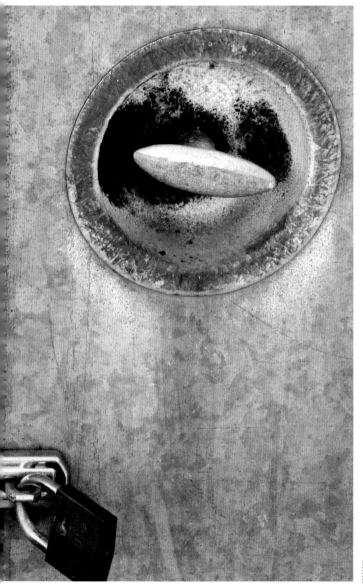

Dr. Jan Daugart
Freedom of Speech

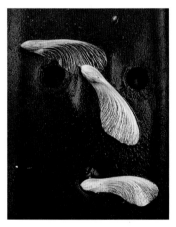

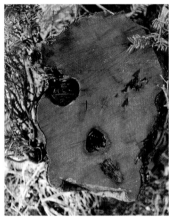

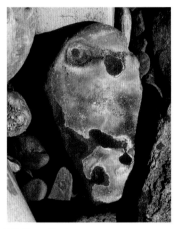

zen Sutherland
Caricature in Iron and Maple Seeds

Anna Mair
Tree Stump Face

Colleen Gustavson
Stone Face

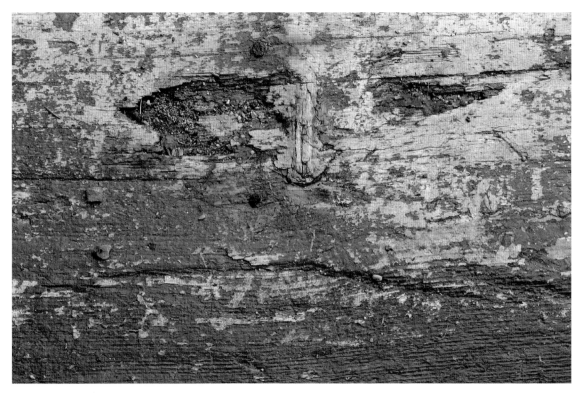

Holly Garner-Jackson
Man on the Stairs

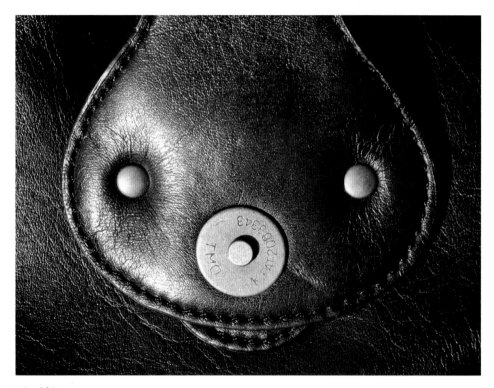

David Dunsmore
Old Bag Face

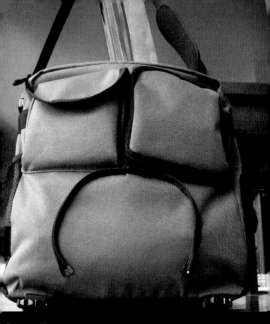

Darren Hunter
Grumpy Old Bag
I came home from work in a bad mood one night and threw my bag over the chair. A few minutes later, I glanced at the bag and saw that it mirrored my own feelings—its frown was directed straight back at me. Funnily enough, this caused my mood to lift

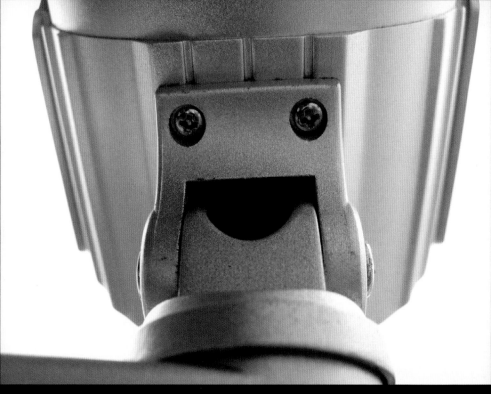

Robert Pataki
Nice to See You Again!

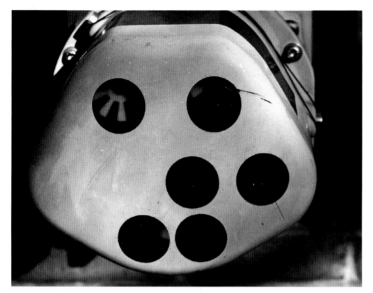

Renee Rendler-Kaplan
Winky's Always Watching

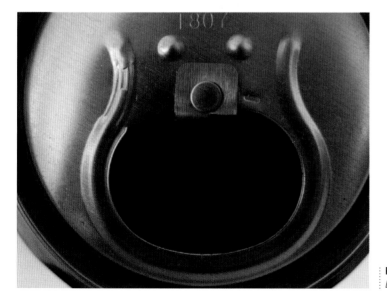

Paula Carolina Zuñiga Garcés
Beer Face

David Dunsmore
Bumper Face

Steve Wrigley
72/365

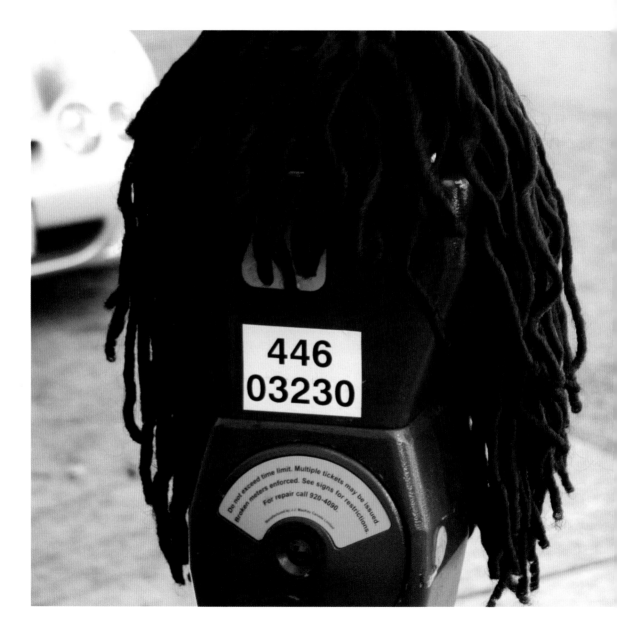

446
03230

Do not exceed time limit. Multiple tickets may be issued. Broken meters enforced. See signs for restrictions. For repair call 920-4090.

Erik Wilson
Wig Parking

Peter Jackson
A Bit of a Wink, I Think

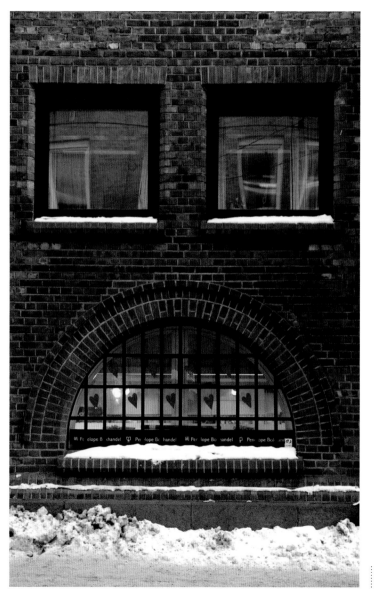

Sigmund Gundersen
A Breath of Hearts

Borys Kozielski
8-;

zen Sutherland
Trestle Face

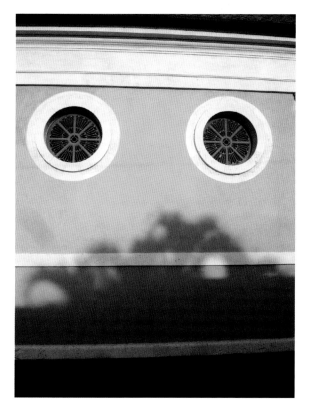

Tarabout Frédéric
8|

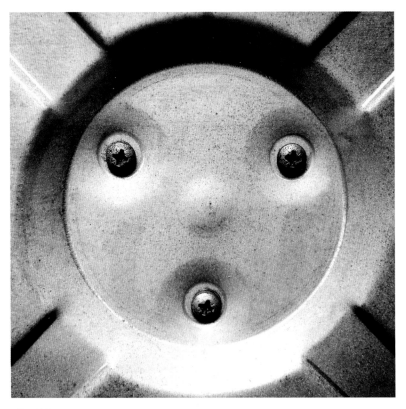

David Dunsmore
Tumble Dryer Face

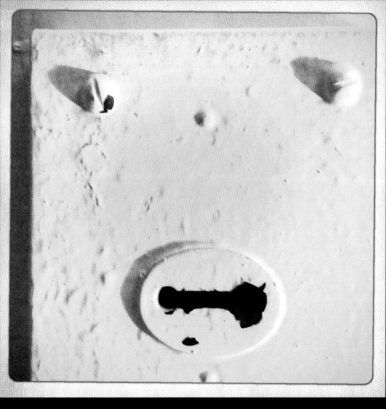

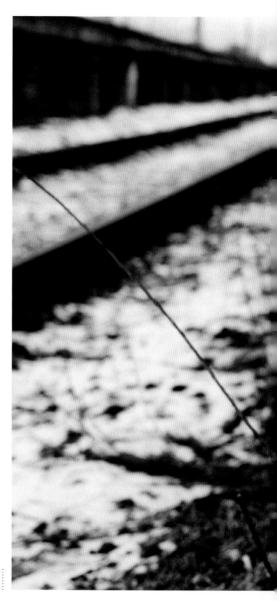

Sven Vahar
Smiles Make Hearts Grow

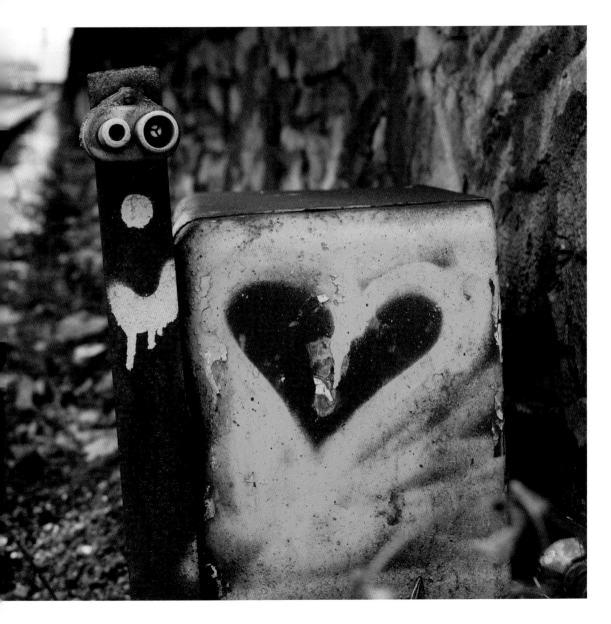

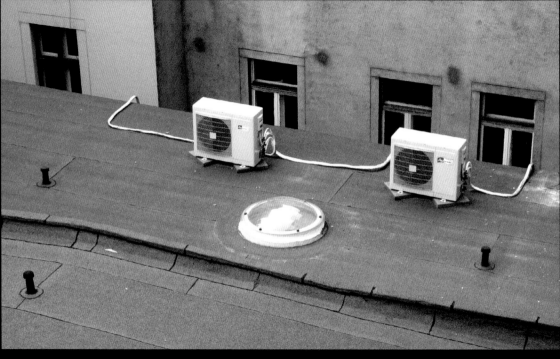

Robert Pataki
The Roof Monster
I found this lonely monster on a roof in Budapest. I shot

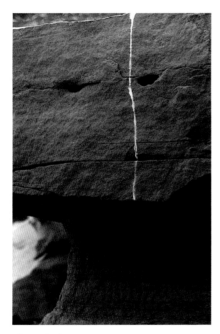

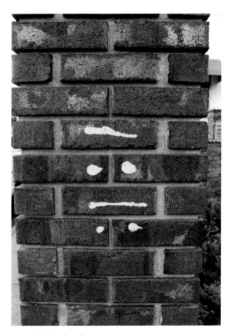

Peter Jackson
An Understandable Expression
This sculptural sandstone face is located just
above the ocean on the east end of Prince
Edward Island in Canada. It's forced to tolerate
the bad manners of the local seabirds.

zen Sutherland
Glyph Face on Brick

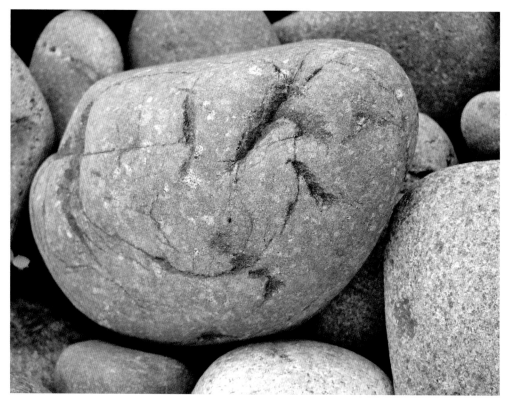

Holly Garner-Jackson
Smile

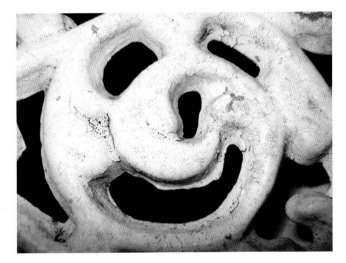

Adam Pelling-Deeves
Drunk Table

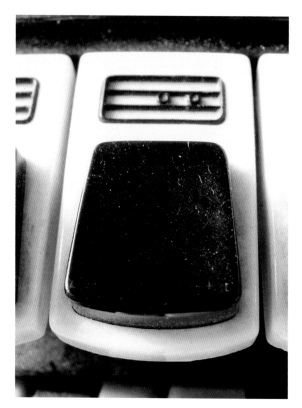

Peter Gubatz
Happy Note

Donna Nicholson-Arnott
Little Accordion Button
I borrowed this accordion from a friend for a photography
project. It was a wonderful object to have around, a real visual
stimulus. I took loads of photographs of it, and when I sifted
through the images later, this little face greeted me.

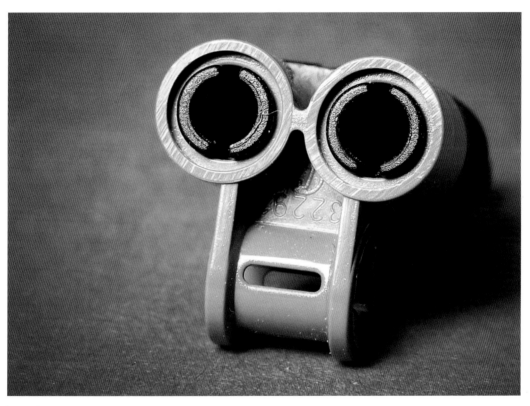

David Dunsmore
Lego Face

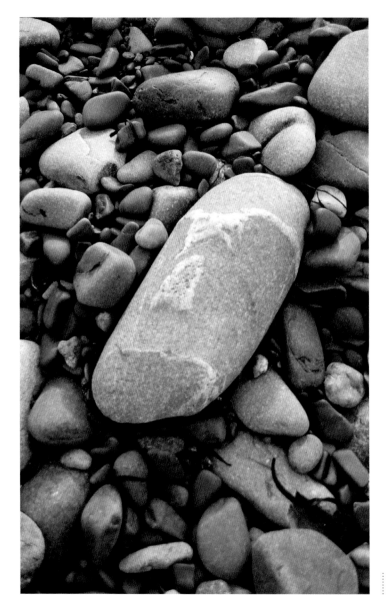

Holly Garner-Jackson
Grumpy

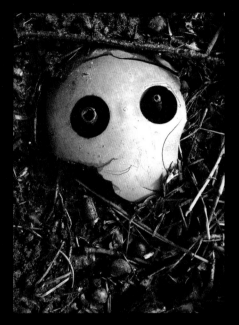

zen Sutherland
Broken Invader Zim Grey Faceplate

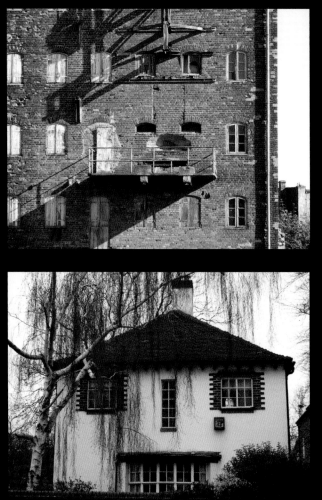

Emma Mykytyn
Happy Building

Anna Mair
Scary House Face

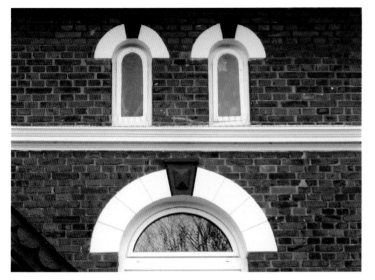

Peter Gubatz
Hamster House

zen Sutherland
Wallface

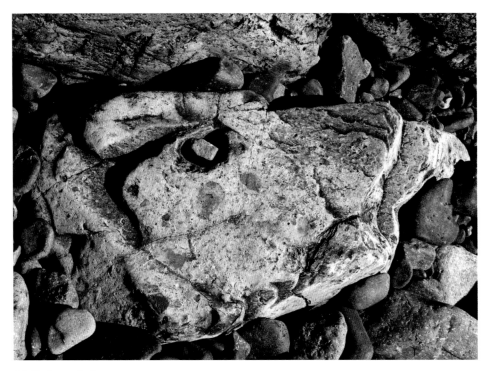

Holly Garner-Jackson
Rock Hound

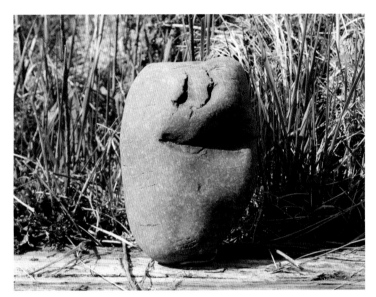

Peter Jackson
Thinks Showing His Tongue is Funny

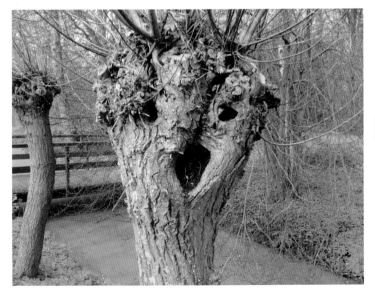

Gerhard Jan Nauta
Oh God, A Photographer!
This tree is near a bicycle path that I use to get to work. One day, the face caught my eye, but I continued on my way. A few minutes later, it dawned on me that I'd seen something curious, and I returned to take a picture. I've passed this startled tree many times since, and I've taken other pictures of it. One day a cluster of mushrooms was growing from its mouth! I wonder how long it will take for those facial features to be wiped out.

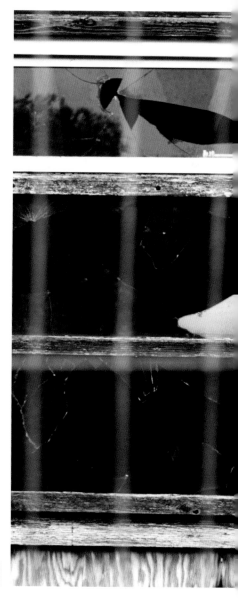

Donna Nicholson-Arnott
Broken Face

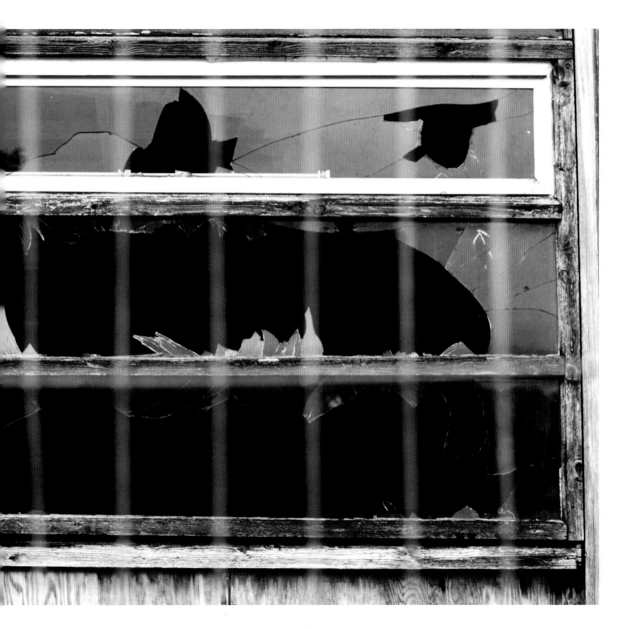

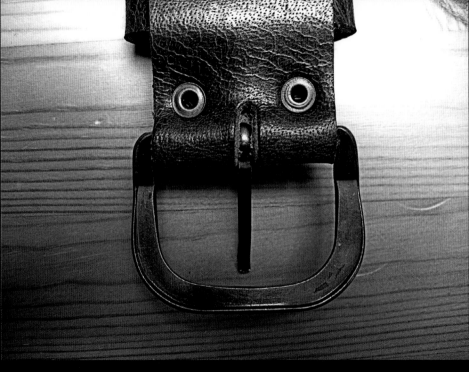

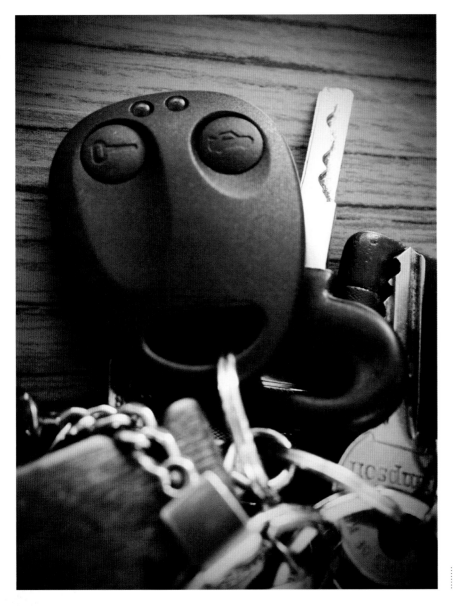

Christian John Olsen
Beeper

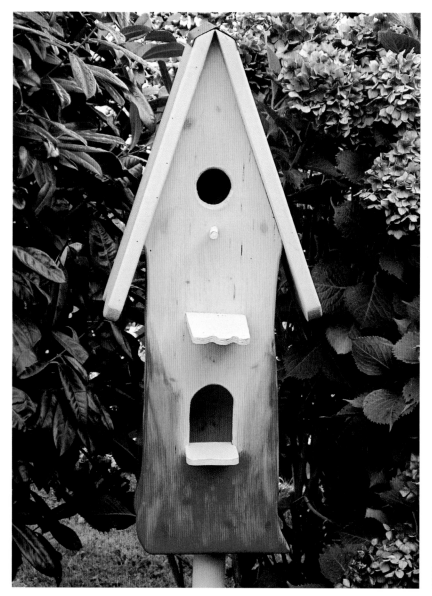

Peter Gubatz
Cyclops

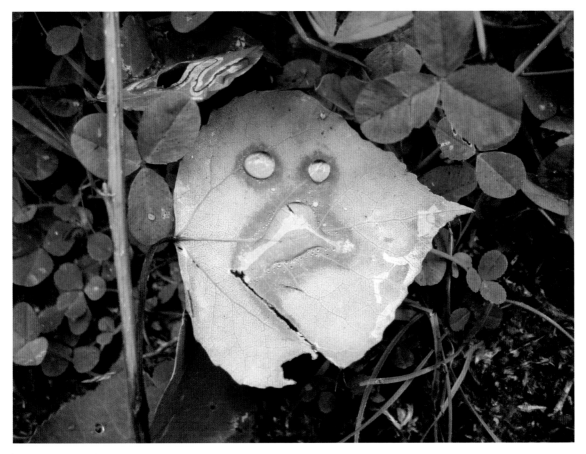

Holly Garner-Jackson
Just Ducky

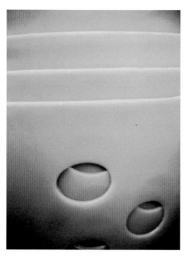

zen Sutherland
Stacked Uh Oh

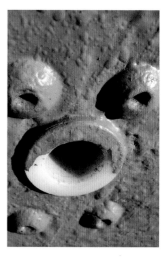

David Dunsmore
Green Door Latch Face

Christian John Olsen
Little Frog

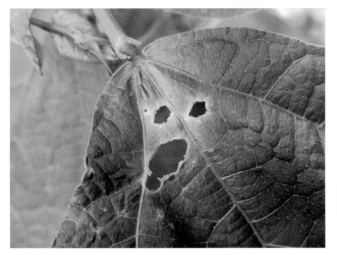

Christian John Olsen
Leaf Screaming
Is this a new evolutionary tactic by the plant to scare away predators, or was it just made by a creative caterpillar?

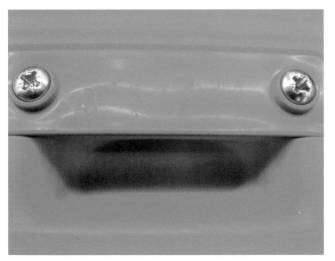

Patrick Dinneen
Starry-Eyed

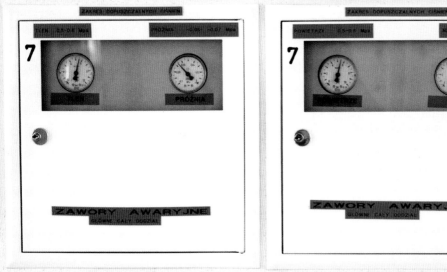

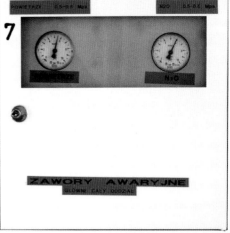

Borys Kozielski
Twins

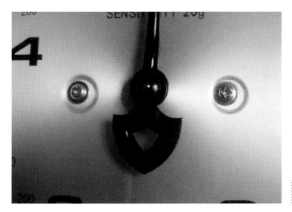

Carmen M. Alcántara Peláez
Happiness Measurer

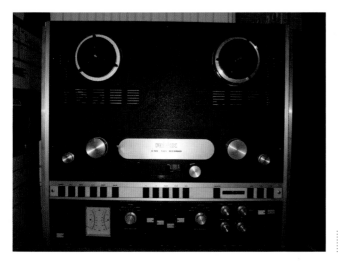

Adam Pelling-Deeves
Startled Tape Recorder

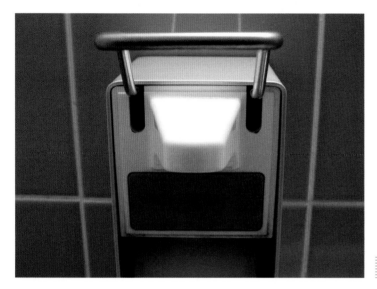

Peter Gubatz
Soapy

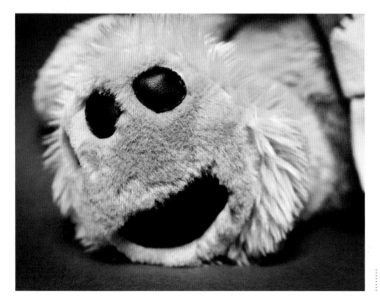

David Dunsmore
Teady Bear's Foot

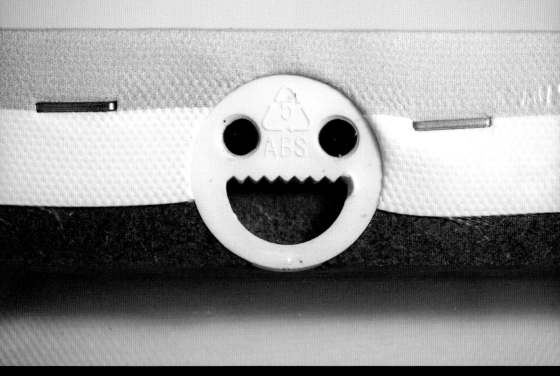

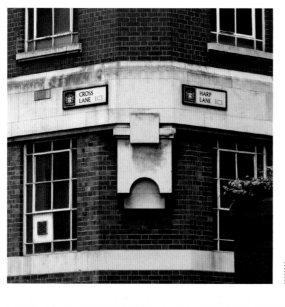

Robert Pataki
A Friendly Hint

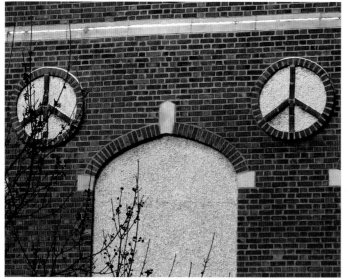

Martin Ujlaki
Peace by Peace

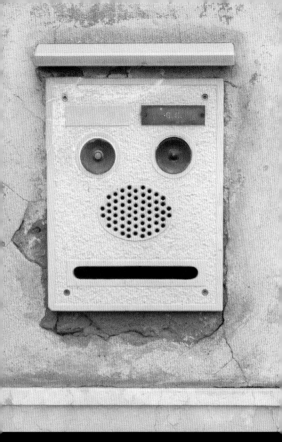

Deb Malewski
Venetian Smile
I was exploring the maze of streets in Venice, feeling a bit lost, when I came across this interesting intercom box next to the front door of an incredibly old house. I saw the face immediately, and it just made me laugh. I wondered: Did people notice that it was a face and maybe even give it a name as they passed it each day?

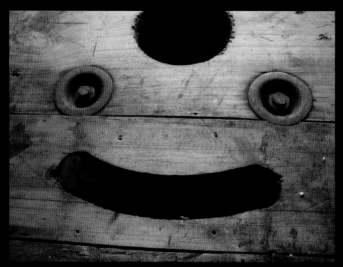

Johanna Hobbs
Smiley
I don't look for them; they look for me.

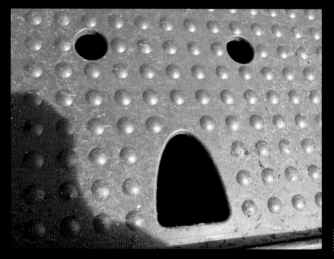

Christian John Olsen
Spotty

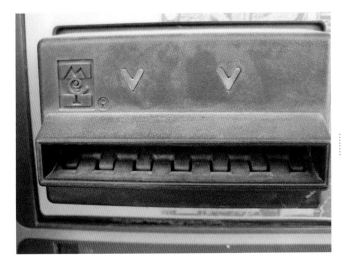

Jonathan H. Liu
Bill Muncher
Each time we pass by the vending machines outside the grocery store, my kids want to push all the buttons. I do my best to hurry them along, but one day we stopped, and I realized there was a face staring out at me, waiting for me to feed it a dollar. I'm sorry to say it went hungry.

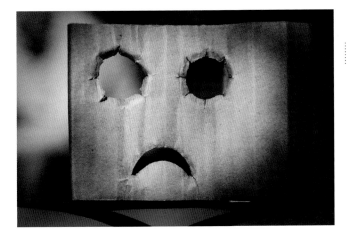

Richard Harrison
Cardbored?
This photo was taken on a hot afternoon in my parents' garden. After taking hundreds of photos of our children playing, my eye started to wander, and I found this sad little cardboard man discarded from the packaging of a playhouse.

My family and friends often think I'm strange when I spot some seemingly random thing and shout, "A face!" Often it's something they've walked past a hundred times without seeing the hidden creature!

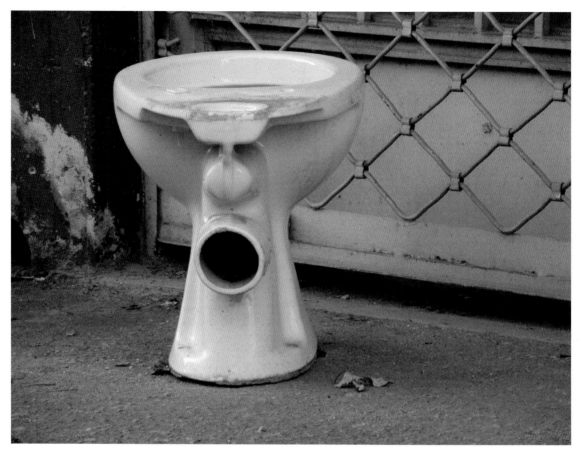

Mario Ermitikos Spiroglou
Awe
When I find a hidden face, I feel like an archeologist. I've discovered and
brought to light something that's been forgotten or overlooked.

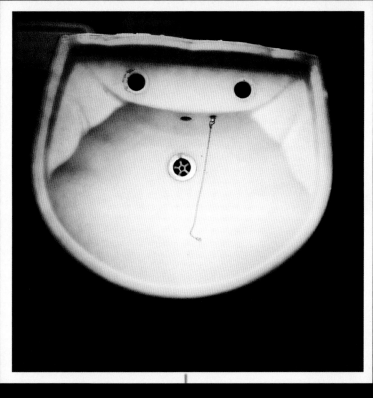

Steve Wrigley
Sinking to New Depths

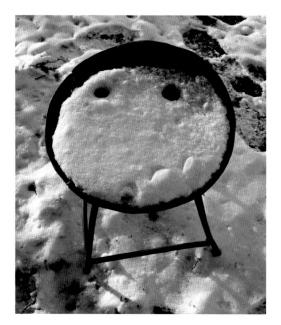

zen Sutherland
Squared Circle Snow Face

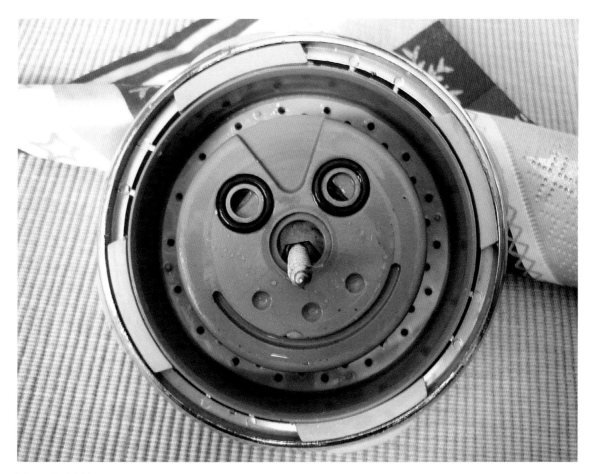

Borys Kozielski
Shower

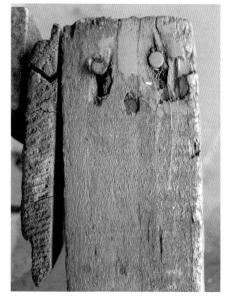

Donna Nicholson-Arnott
Face on the Gate

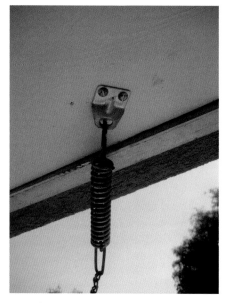

Jonathan H. Liu
Sprung

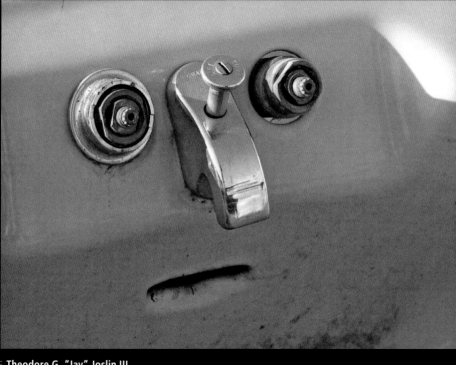

Theodore G. "Jay" Joslin III
Sinking Feeling II

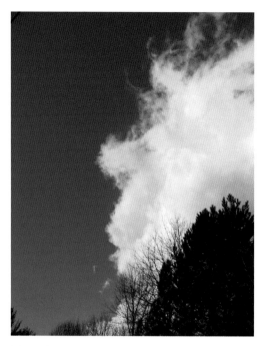

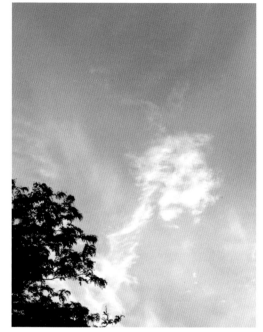

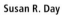

Susan R. Day
Sunny Winter Skies
Finding a face lets me know that I better
be good because someone is watch-
ing me. It also reminds me that I have
friends of all kinds, even in the most
unexpected places!

Martin Ujlaki
Face in the Clouds

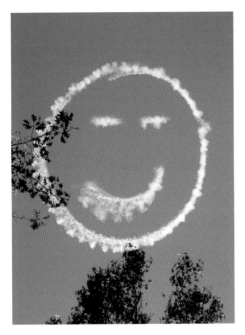

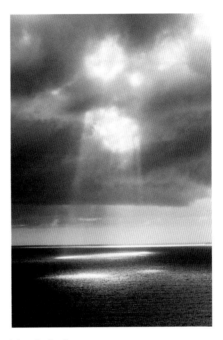

Heather Sostrom
Smiles in the Sky

Lyndie Pavier
Cumulus Countenance
I took this photo during a vacation on the north coast of Kwa-Zulu Natal in South Africa. I was miserable on the morning I shot this picture because the sky was overcast, which meant that I wouldn't get any shots of the sunrise. To my surprise, nature worked its magic, and I was able to capture this face in the clouds. I realized then that you don't need perfect weather to capture a stunning image. The face definitely brightened my day. This photo really made me feel as though I'd captured a moment in time.

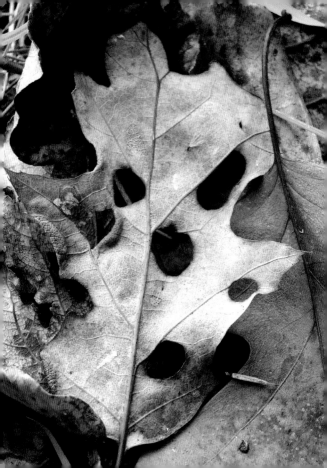

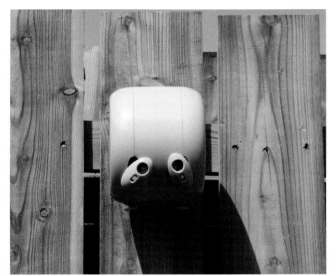

Emma Mykytyn
Washing Day Blues

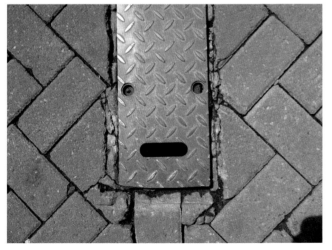

Patrick Dinneen
Walk All Over Me!

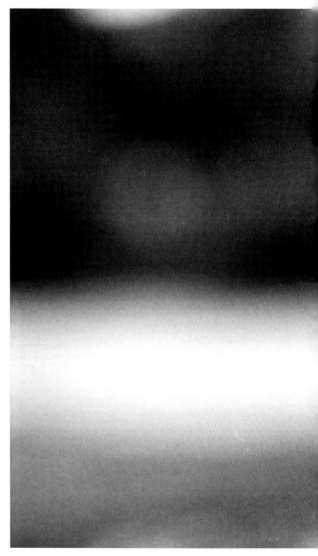

Tina Trillitzsch
Happy Pole

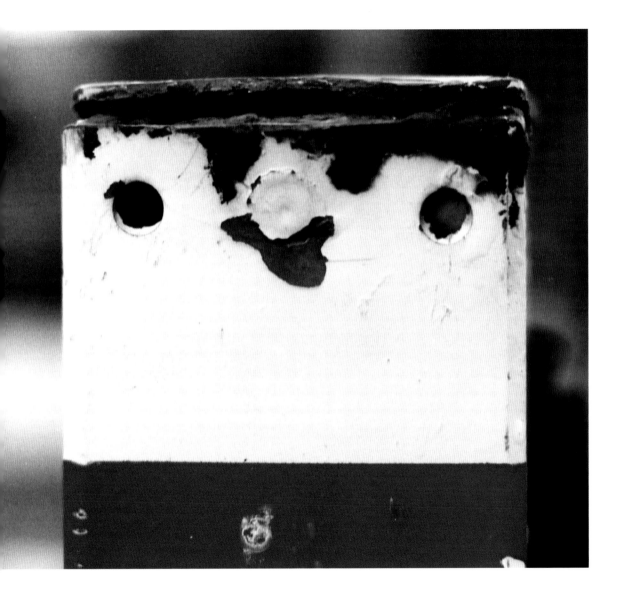

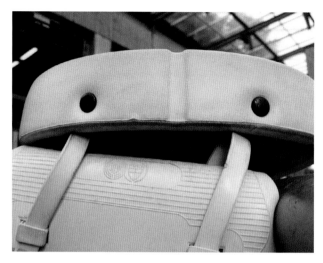

Robert Pataki
Mr. Big White

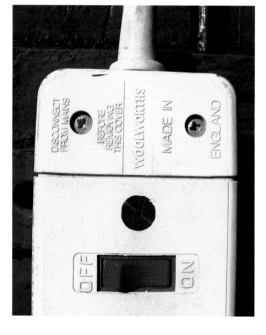

David Dunsmore
Turned On Face

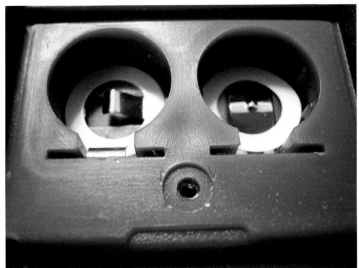

Christian John Olsen
Battery Boy
This cheeky chap was found while replacing the
batteries in an electronic toy.

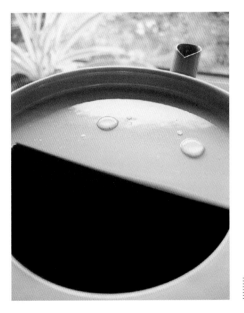

Christian John Olsen
I Can See You

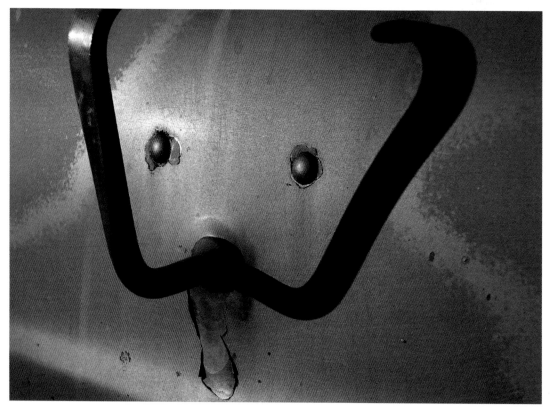

Colleen Gustavson
Don't Hate Me Because I'm Beautiful

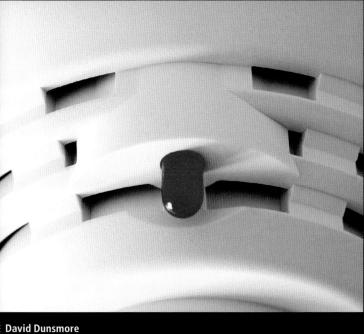

David Dunsmore
Smoke Alarm Face

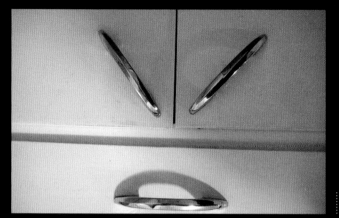

Jonathan H. Liu
Angry Cabinet

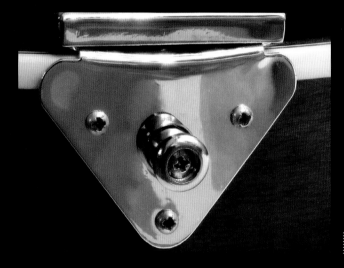

David Dunsmore
Mandolin Face

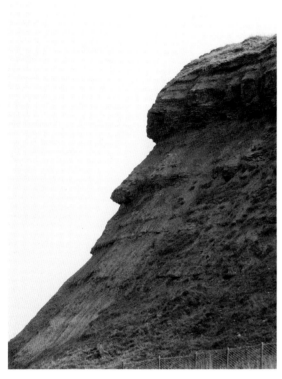

Cathy McBurney
Cliff Face

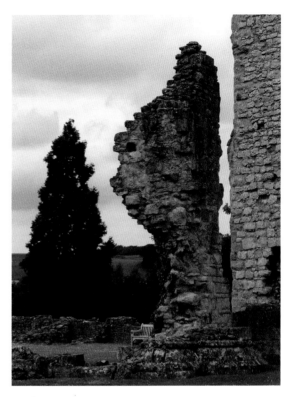

Cathy McBurney
Old Head
A profile in the ruins at Helmsley Castle, England. This face looks like an Asian dancer or warrior.

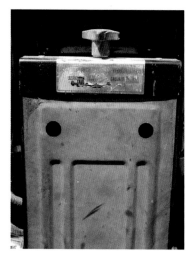

Ileana Wranke
Mit Hut

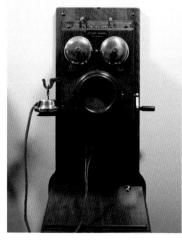

Dennis Irrgang
Hello World!
This picture was taken during a tour of the Museum for Communication in Frankfurt, Germany. There was a big display of different kinds of phones sorted from old to new, and that's where I found this one. It was staring at me.

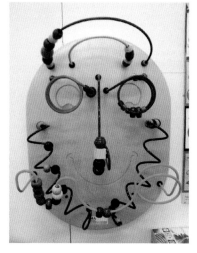

Patrick Dinneen
Toy Smile

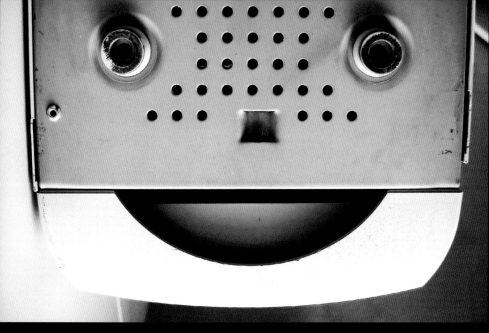

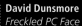
David Dunsmore
Freckled PC Face

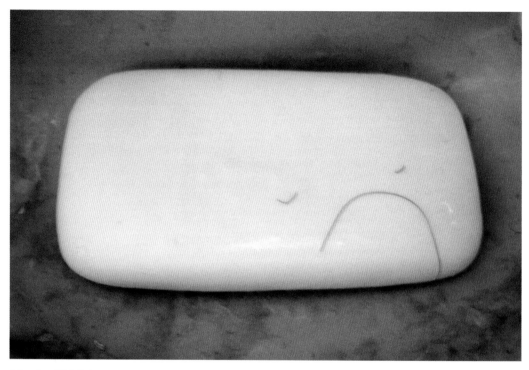

Tarabout Frédéric
u_u
Soaps have feelings too. This one was apparently
bummed after its use in the bathroom.

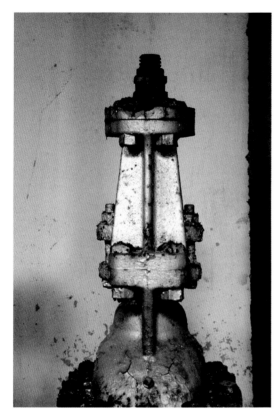

zen Sutherland
Face Metal Equipment

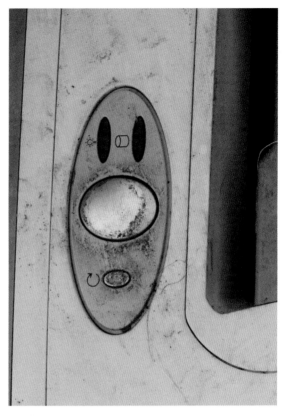

Cathy McBurney
Worried Computer

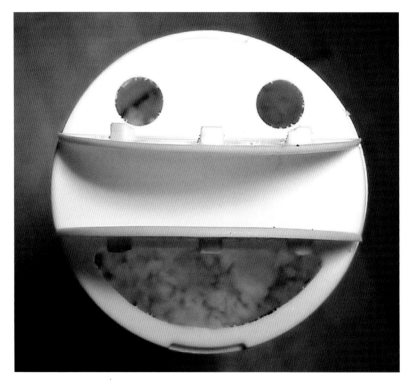

David Dunsmore
Cheesy Grin

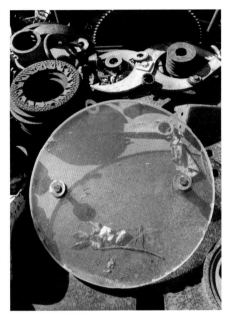

zen Sutherland
Squared Circle Glass Plate

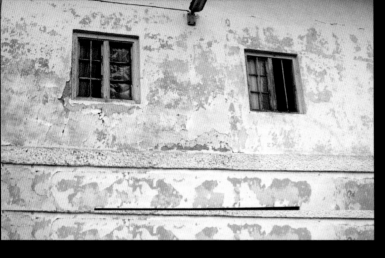

Ileana Wranke
Gesicht

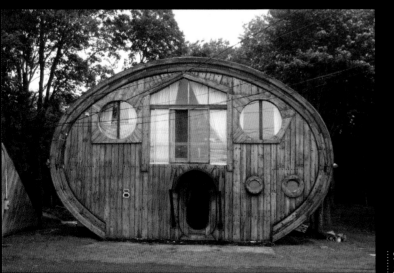

Stephen G. Reed
Surprised House, Long Island

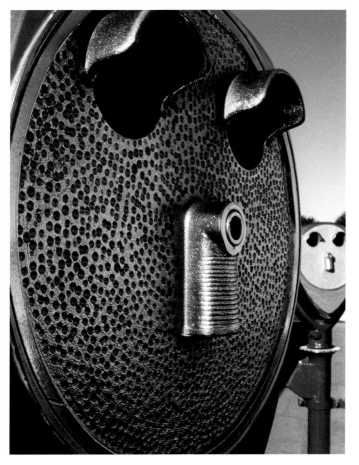

Kari Quaas

Longing

My image features two telephoto viewfinders that I happened upon while sightseeing in Monterey, California. Finding a face in an inanimate object is like walking down the street and saying hello to a stranger. By instinct, we try to make familiar what's unknown to us. Finding faces is a way to connect with the world.

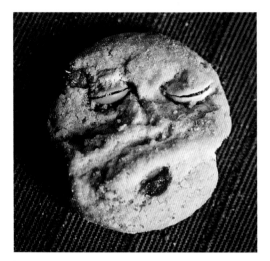

David Dunsmore
Smartie Cookie

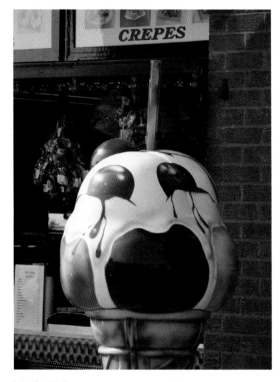

Cathy McBurney
I Scream

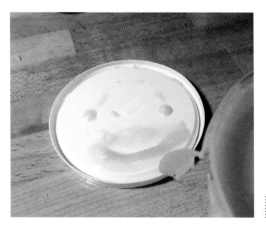

Peter Lindberg
Honey Boy

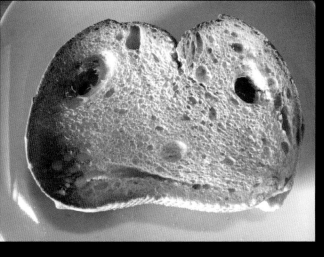

Steve Dini
Toast Face

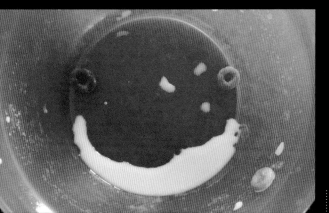

Patrick Dinneen
Cereal Smiler

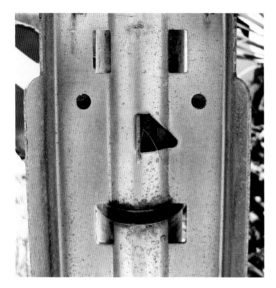

David Dunsmore
Bus Stop Timetable Face

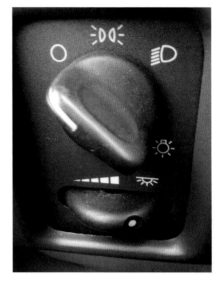

Brian Platt
Say Ah

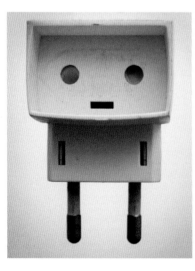

Carl Andersson
=|

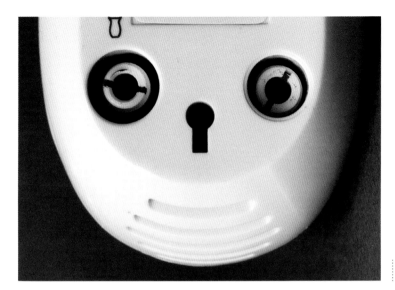

David Dunsmore
Electric Whisk Face

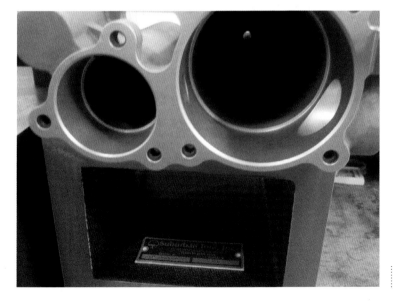

Brian Platt
Lights, Camera, Action

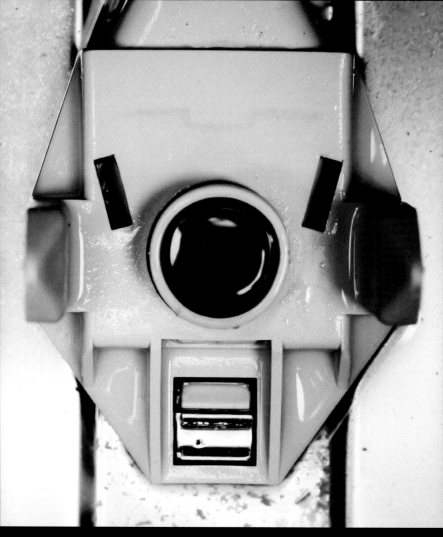

David Dunsmore
Dishwasher Outlet Face

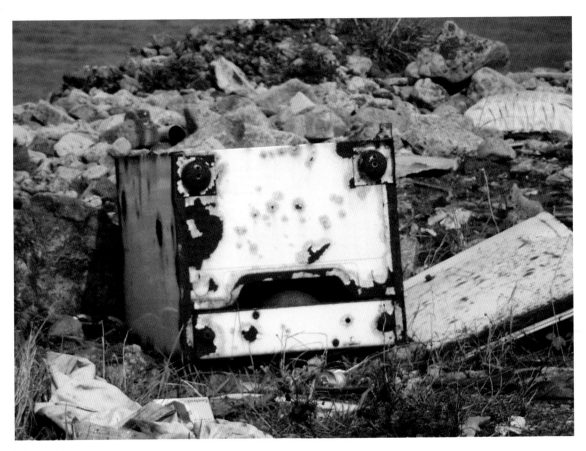

Cathy McBurney
Freckle Face

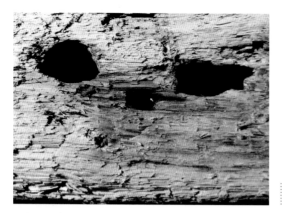

Holly Garner-Jackson
Meet Woody

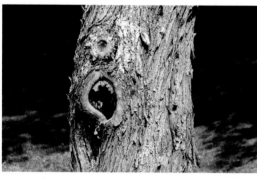

Peter Jackson
Victim of a Frightful Night

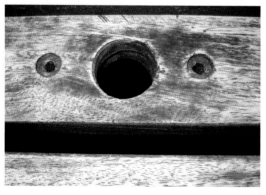

Adam Pelling-Deeves
Contented Bear Table

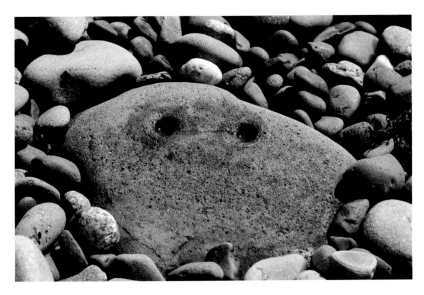

Peter Jackson
Been Crying a Little

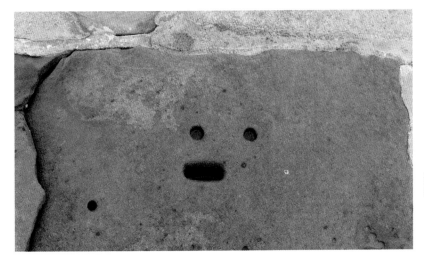

Cathy McBurney
Happy Pavement
I found these holes in a flagstone
on the pier in Whitby, England.
He looked so happy that I stepped
around him.

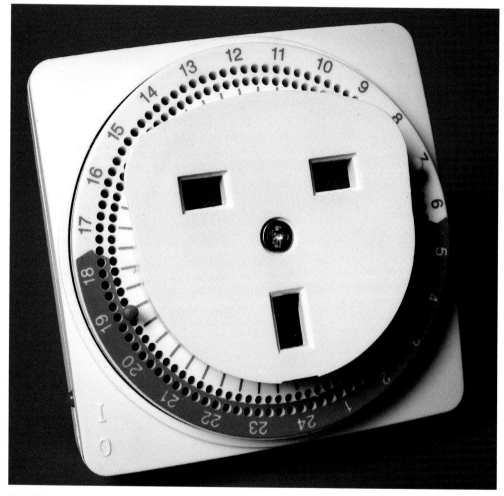

David Dunsmore
Electrical Shocked Face

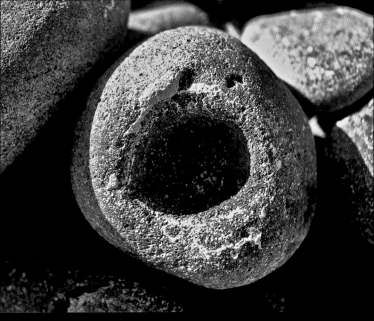

Peter Jackson
Who Was Using My Razor?
This was a beach rock I came across while walking on the shore on Campobello Island in New Brunswick, Canada. It was encrusted with dried sea foam and salt, but it said shaving cream to me.

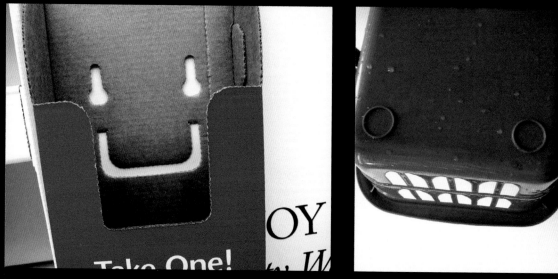

Noah H. Eggensperger
Happy Shopping

Christian John Olsen
Sweaty Grinner

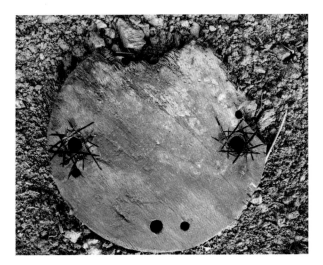

zen Sutherland
Goodbye Kitty

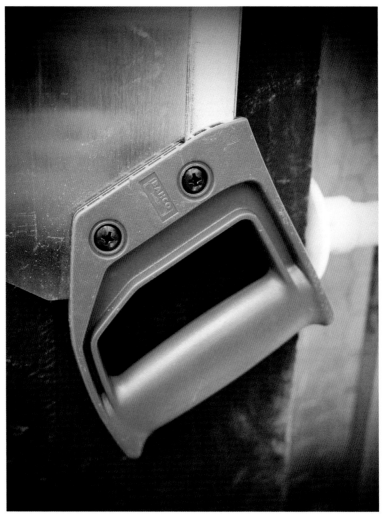

Christian John Olsen
I Saw a Face

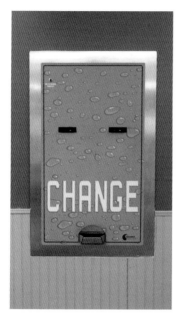

zen Sutherland
AVL Meetup Wet Change

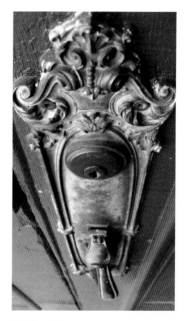

Colleen Gustavson
Lion Found Courage

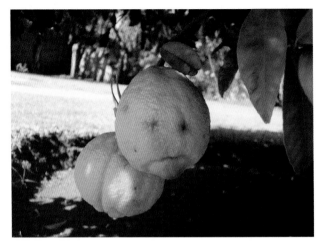

Jacqui Brown
Glum Lemon

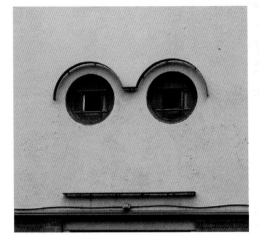

Martin Ujlaki
Building Face

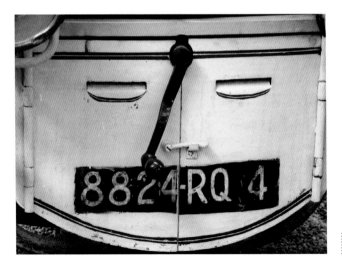

Valéne Joly
Le Sommeil de la Vieille Mécanique

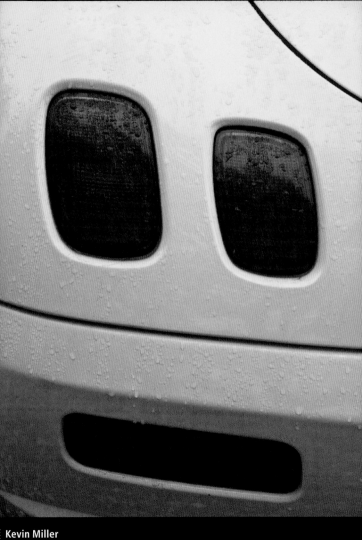

Kevin Miller
Not So Mellow Yellow

Index of Contributing Artists